NETSUKE

Masterpieces
from
The Metropolitan
Museum of Art

NETSUKE

MASTERPIECES FROM THE METROPOLITAN MUSEUM OF ART

By Barbra Teri Okada

THE METROPOLITAN MUSEUM OF ART

Harry N. Abrams, Inc., Publishers, New York

©1982 by The Metropolitan Museum of Art, New York

Published by The Metropolitan Museum of Art, New York
Bradford D. Kelleher, Publisher
John P. O'Neill, Editor in Chief
Project Supervisor: Joan Holt
Editor: Kathleen Howard
Designer: Dana Levy

On the cover: Elephant and Blind Men (no. 93).

The photographs in this volume were taken by Walter J. F. Yee,
Photograph Studio, The Metropolitan Museum of Art.

Composition by LCR Graphics, Inc.
Printing by The Arts Publisher, Inc.

Translations of poems in the surimono print by the Rev-
erend Hozen Seki.
Translation of poem on p. 101 by Edwin A. Cranston,
reprinted by permission from John M. Rosenfeld and
Fumiko E. and Edwin A. Cranston, *The Courtly Tra-
dition in Japanese Literature* (Fogg Art Museum, Harvard
University, 1973), p. 183.

Library of Congress Cataloging in Publication Data

Metropolitan Museum of Art (New York, N.Y.)
 Netsuke: masterpieces from the Metropolitan Museum of Art.

 Bibliography: p. 115
 Includes index.
 1. Netsukes—New York (N.Y.)—Catalogs.
2. Metropolitan Museum of Art (New York, N.Y.)—Catalogs. I. Okada,
Barbra Teri. II. Title. NK6050.M44 1981 736'.68'07401471 81-38344
 ISBN 0-87099-273-2 AACR2
 ISBN 0-8109-1361-5 [Abrams]

Contents

Foreword

WHEN THE MEIJI RESTORATION ENDED over two hundred years of Japanese isolation from foreign cultures in the mid-nineteenth century, Western collectors rediscovered the art of Japan. One of the most popular art forms was that of netsuke, richly carved small toggles used to suspend articles such as pouches or cases from the traditional *obi,* or sash. Westerners were fascinated by the small size and intricate detail of these little sculptures, which depict a wide variety of subjects—encompassing almost every facet of Japanese life, history, and culture. Genre scenes, characters from Shinto, Taoist, and Buddhist legend, real and mythological beasts, plants and flowers—all have been treated in netsuke, in myriad techniques, materials, and styles.

In 1910, Mrs. Russell Sage, one of the Metropolitan's first great benefactors, presented to the Museum a group of 2,500 pieces she had purchased from A. C. Vroman of Pasadena, California. This collection was considered to be the largest and finest in the United States at the time. Since then, notable pieces have been given by Edward C. Moore, Stephen Whitney Phoenix, and Mrs. H. O. Havemeyer, who along with her husband possessed one of the few great early collections of Japanese art in the United States. The Museum's collection is especially strong in nineteenth-century examples, but the eighteenth and early twentieth centuries are also represented by outstanding pieces in this rich selection of 100 of the finest netsuke from The Metropolitan Museum of Art.

PHILIPPE DE MONTEBELLO
Director

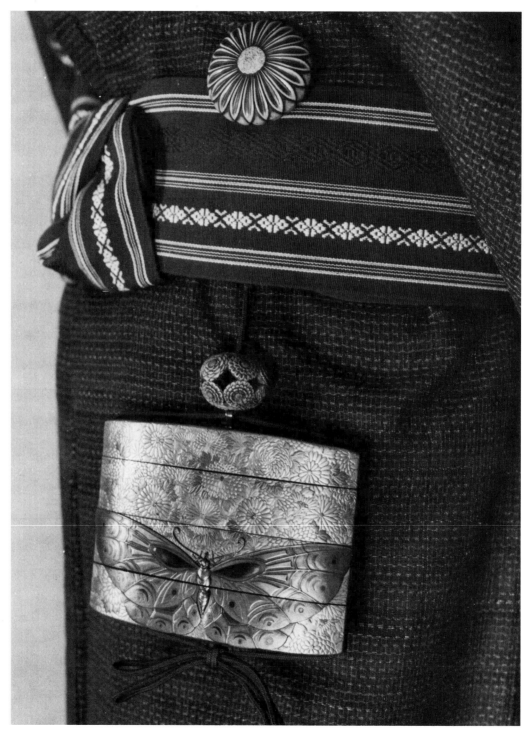

The ensemble above—netsuke ojime, and inrō—is shown as it would have been worn, hanging from the obi on the right side. The left side was reserved for the wearing of a sword or swords.

Introduction

DURING THE EDO PERIOD (1615–1867) a highly original and spirited new art form evolved and flourished in Japan. This was netsuke, small sculptures uniquely designed to be worn, an ingenious and decorative means of suspending objects from the traditional sash, or *obi,* which was wrapped around the kimono. The demand for netsuke largely grew out of the fashion for carrying bulky items, such as tobacco pouches, purses, and the tiered boxes called *inrō* (literally, "seal case")—originally used to hold seals, and later medicine—which were difficult to tuck into the folds of the pocketless kimono or too heavy to insert into its sleeves.

Customarily, these *sagemono,* or "hanging things," which could be objects as heavy as a writing case or sake container, were strung on a cord that passed through a sliding bead (*ojime*), which acted as a tightener, and then was threaded through a toggle—the netsuke—and knotted. The cord was passed under the obi from below so that the netsuke perched on top of the sash, while the sagemono hung securely a few inches below it.

Although a netsuke could be as simple as a stick with two holes in it or as elaborate as a piece of fine jewelry, its function placed certain restrictions on material and design. It had to be small enough to slide easily under the obi but bulky enough to keep the sagemono from slipping down. It had to be made of a durable smooth

The demand for netsuke grew out of the fashion for carrying bulky items, which were too large to tuck into the folds of the kimono or too heavy to insert into its sleeves.

This richly lacquered, tiered *inrō* (literally, "seal case") is suspended from an ivory chrysanthemum-shaped netsuke.

The sliding bead, or *ojime*, is also decorated with chrysanthemums. Early nineteenth century. Inrō signed: Shōfusai Tō-sen. Gift of Mrs. George A. Crocker (Elizabeth Masten), 1937, 38.25.150

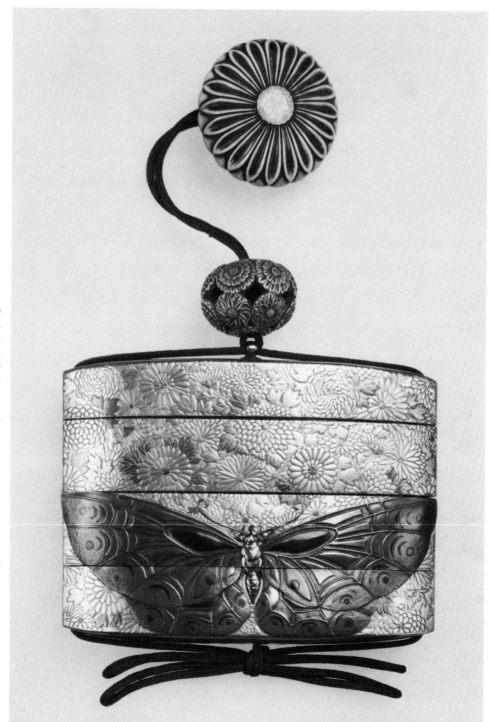

substance to withstand rubbing and resist cracking. Furthermore, the cord openings (*himotoshi*) had to be incorporated into the composition in such a way that the netsuke would hang properly and the knot would be as inconspicuous as possible. In many early examples the openings were part of the design itself, but more often they were cut into the back or underside.

Fine netsuke are carved on all surfaces including the underside. Most are superbly balanced and will stand unsupported on a flat surface. Even slender pieces six or seven inches high will remain upright by themselves.

Part of the appeal of netsuke is their smooth, agreeable feel, a special quality called *aji,* by which the artist communicates his spirit through touch as well as sight. Aji is enhanced by handling, which also produces a patina that gives luster to wood and mellow tints to ivory.

Netsuke have depicted a multitude of subjects and have been made from practically every material found in Japan. The simplest and probably the earliest were of stone, shell, walnut shells, and small gourds. Later and more sophisticated ones were carved from ivory and wood, particularly boxwood, cypress, ebony, cherry, pine, and bamboo. Less commonly employed were bone, metal, and lacquer, although the last was one of the earliest materials, used for netsuke created to match lacquer inrō. Occasionally, netsuke were made from hornbill or amber.

Several varieties of ivory were used. Until well into the nineteenth century, marine ivories and elephant ivory, which came mainly from India through China, were imported into Japan. Elephant ivory was used for plectra for the koto, a stringed instrument, and leftover pieces were sold to netsuke carvers. The rarest and most precious of marine ivories came from the tusk of the narwhal, credited with medicinal and magical powers. Two major schools of artists used deer antler and the teeth and tusks of wild boar as their mediums.

Netsuke are classified according to their distinctive forms. An early type, the *sashi* (literally, "thrust between"), was long, narrow, and usually made of wood, with the openings at the top. It was meant to be inserted behind the obi, leaving the cord on the outside and the sagemono swinging freely. Later sashi had additional openings lower down and farther apart.

The most prevalent form, with the widest variety of subjects and materials, was that of small sculptures called *katabori,* or "carving on all sides." Although they could be almost any shape, katabori are generally compact, in keeping with their use.

Manjū netsuke derive their name and shape from the round, flat rice cake eaten mainly at the Japanese New Year. The simplest were made of solid pieces of ivory with a cord hole in the center. A variation developed, first in wood and then in ivory, that had two halves that swiveled to open.

The *kagamibuta* ("mirror lid") is a rounded shape having a disk, or lid, commonly of metal, set into a bowl of ivory or wood. This lid can be opened by releasing the tension on the cord, which is strung through the back of the bowl. Decoration was

In the wood-block print by Torii Kiyonaga (1752–1815), the actor Nakamura Matsue is being dressed by an attendant who carries a pouch on a cord that is threaded through the beadlike ojime, passed under his sash, and secured at the top by a netsuke.

Frederick C. Hewitt Fund, 1911, JP 727

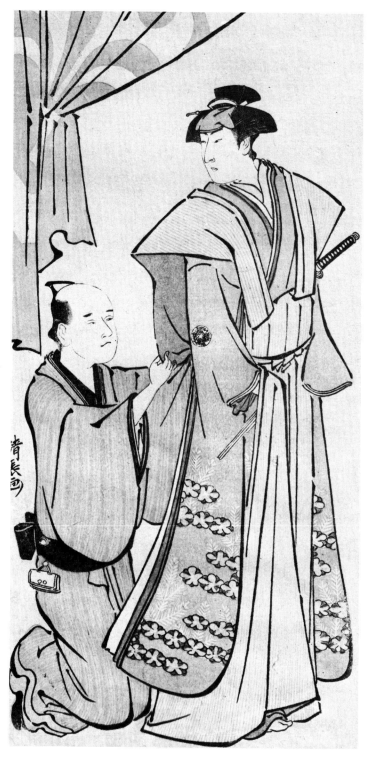

usually restricted to the metal, but in rare examples the bowl was elaborately carved as well.

Ryūsa netsuke, named for the eighteenth-century carver said to have originated them, were hollowed out with a turning lathe, a method that made possible delicate openwork designs and a lightweight form.

Mask netsuke were diminutive versions of those worn in the traditional dance-dramas of Japan. The earliest, mainly of wood, were created by mask carvers seeking to copy the originals, but later examples became stylized and even comical.

Many netsuke had secondary functions. There were ashtray netsuke for transferring smoldering ashes from the spent pipe into a bowl of unlit tobacco. Other useful items that could be found among netsuke were compasses, whistles, sundials, abaci, brush rests, cases for flints and steels, and even firefly cages.

The growth of netsuke was stimulated by social changes of the sixteenth and seventeenth centuries affecting fashion in sagemono. Soon after Tokugawa Ieyasu (1542–1616) became shogun in 1603, he instituted stringent controls to ensure his supremacy and maintain peace. A strict Neo-Confucian code was established. Japanese society was stratified into classes. The highest included the samurai, and it was followed by the farmer, artisan, and merchant classes. Laws governed private conduct, dress, marriage, and, for some, place of residence. Although the highest class was subject to sumptuary laws, samurai were allowed to wear two swords as symbols of their rank. With no wars to fight, sword blades and fittings became more decorative than practical, and wealthy samurai lavished enormous amounts of money on them.

On formal occasions samurai sometimes wore inrō. Since, like sword fittings, they were not subject to sumptuary laws, inrō also became objects for show, and were elaborately embellished with gold and other precious materials. At first only the samurai class could afford them, but eventually they were adopted by the prospering members of other classes as well, and soon many wore inrō with matching netsuke.

Meanwhile, a parallel social and economic development spurred a second fashion in sagemono. When the Portuguese introduced tobacco into Japan in the sixteenth century, smoking took hold immediately. Crops were planted in southern Kyushu, and soon the majority of Japanese were enjoying pipes, although it was considered improper for members of the upper classes to smoke outside their homes. An edict forbidding the use of tobacco was passed in 1609, primarily because the habit was considered unsanitary, but the law was difficult to enforce and was finally repealed in 1716 in the hope that the tobacco crop would help the economy.

The repeal encouraged smoking. Among tradespeople, it became an integral and almost ritualistic part of any business transaction. The demand for portable implements—pipe cases, tobacco pouches, and lighting devices—increased, and with it the production of netsuke. As a large percentage of the male population began smoking, hundreds of thousands of examples were created in various styles and qualities.

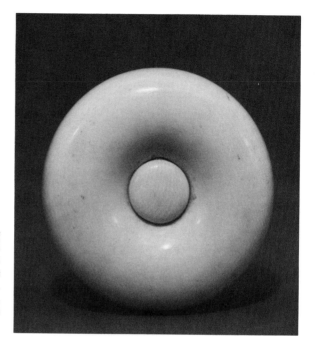

The precursor of the netsuke carved in the round was a wheel or doughnut-shaped object, as seen here. It soon acquired a center peg with a needlelike aperture which hid the cord opening from view. Eighteenth century. Ivory, diameter 1¾ inches. Gift of Charles Greenfield, 1977, 1977.446

By the mid-eighteenth century virtually every Japanese male carried one or more sagemono requiring netsuke. Artisans such as mask makers and Buddhist sculptors, who originally carved netsuke only as a sideline, began to specialize in them. By the end of the eighteenth century, netsuke carving was no longer considered an insignificant pastime, and artists began to sign their works and form schools with local and regional traditions.

By 1781 Inaba Tsūryū (Shineimon) of Osaka, a connoisseur of sword fittings, could devote almost one volume of the seven of his *Sōken Kishō* (which may be translated as "A Treasury of Sword Fittings and Rare Accessories") to fifty-five netsuke carvers of his day and their designs. The cursory text discusses artists working in Edo (now Tokyo), Osaka, Kyoto, and Wakayama, and suggests that they had originally produced other forms of sculpture, such as masks, Buddhist images, and architectural details, before turning to netsuke. He fails to mention what might be regarded as the first school of netsuke artists—the earliest group having a definite stylistic relationship—who worked in southern Honshu, in Iwami Province. By the nineteenth century, however, many of the carvers cited in the *Sōken Kishō* had come to be considered originators of schools in their own right.

Earlier written descriptions of the development of netsuke do not exist, and since few seventeenth-century examples survive, we have to rely on scrolls, screens, and prints for a pictorial record. In the *Kabuki Sketchbook Scroll* (in the Tokugawa Rei-

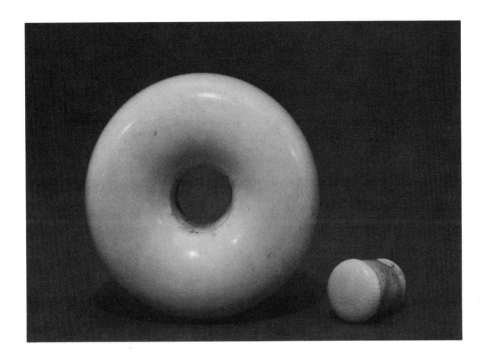

meikai Foundation, Tokyo), dating from the first half of the seventeenth century, an actress is shown wearing an assortment of articles suspended from a large ring around the narrow obi. The next style, depicted in a screen of the second quarter of the century, was a disk or wheel shape (later the manjū), which toward the middle of the century acquired a center peg with a hole for the knot. Small sculptures in the round are not illustrated much before the eighteenth century.

Fortunately, many fine netsuke remain from about the 1750s on. Early eighteenth-century examples are usually large, spirited, and original in design, being more direct expressions of their creators' personalities and geographical locations than later pieces. For instance, Osaka netsuke reflected the vitality of a bustling commercial center, while those made in Kyoto, the ancient imperial city, were dignified and restrained, and artists in the remote area of Iwami were interested in naturalistic local subjects rendered in indigenous materials.

Since there was no established tradition to follow, the artists of the eighteenth century enjoyed a freedom of interpretation. As netsuke were unimportant in the eyes of the government, no attempt was made to regulate them. Parody, satire, and parable could be used without fear of censorship. Moreover, with traditional religious sculpture in decline by the Edo period, netsuke provided an opportunity to express religious thought and feeling.

Subject matter was largely derived from Chinese and Japanese legends, religion,

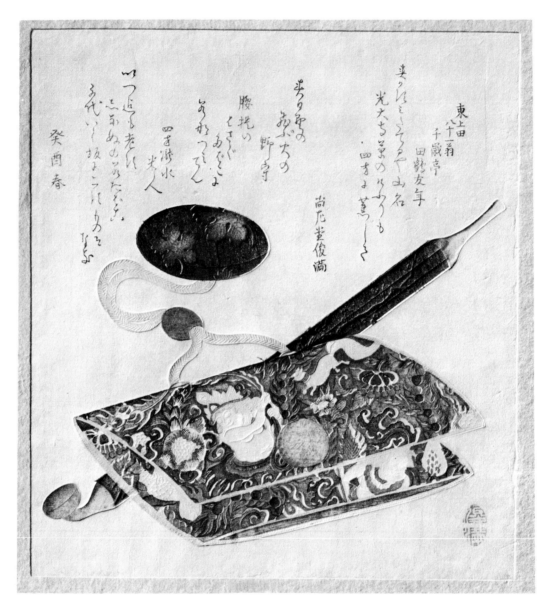

A *surimono* (a special commemorative print), dated spring 1813, depicts a manjū netsuke, tobacco pouch, and pipe, which made up the traditional Japanese smoking ensemble. The middle verse, written by the artist, Kubo (Shōsadō) Shunman (1757–1820), refers to the guard watching the "flying fire of Kasuga" (a fire set annually in the fields near the Kasuga Temple at Nara), who takes out his smoking implements and fills his pipe.

In the corner of spring stands the mountain of Kodai-ji; the sweet smell of grass surrounds it in four directions. —Tazuru Tomotoshi [real name]/Sensaitai [pen name]/An old man of eighty-one years/Higashi Ueda [place]

The guard who watches the flying fire of Kasuga takes out his *sage* [smoking ensemble] and fills his pipe. —Shōsadō Shunman

Never getting old and dying, the guard smokes his tobacco—the smoke forever ascending—without fear. —Shisai [pen name]/Takimizu Yoneto [real name]

The H. O. Havemeyer Collection, Bequest of Mrs. H. O. Havemeyer, 1929, JP 1954

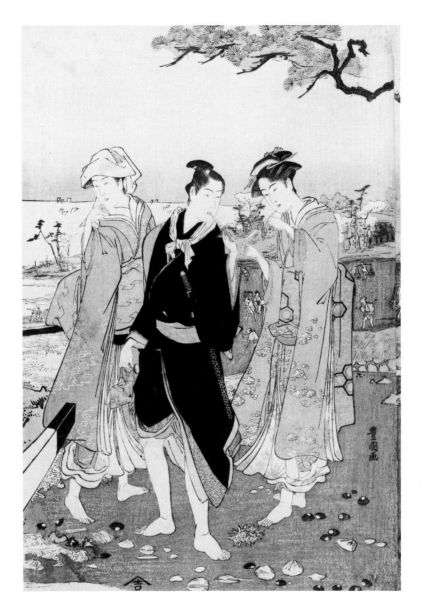

The man smoking a pipe, from the center panel of a wood-block triptych of shellfish gatherers by Utagawa Toyokuni (1769–1825), holds an ashtray netsuke that is attached to his tobacco pouch.
Rogers Fund, 1914, JP 204

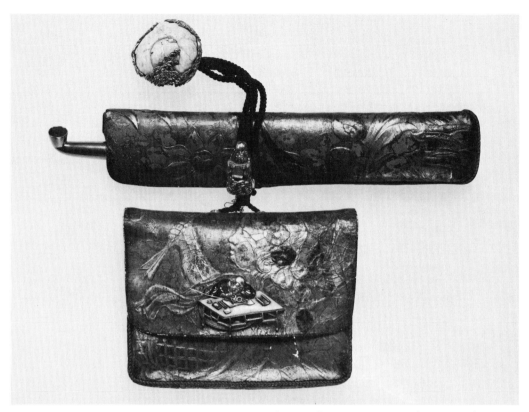

This richly decorated smoking ensemble, consists of a netsuke, a pipe case (and pipe), and a tobacco pouch. In the netsuke a gold mounting, simulating waves, holds a freshwater pearl which looks like an island surrounded by water. The gold ojime—the figure of Jūrojin, one of the seven happy household gods—symbolizes good fortune. The pipe case and tobacco pouch are made of lacquered leather on which religious symbols from both Buddhism (the lotus flowers) and the West (the angel) have been embossed. The clasp on the pouch shows a scholar at rest, his glasses placed on his writing table.

Nineteenth century. Tobacco pouch: leather, length 5¼ inches, height 4 inches; pipe case: leather, length 9 inches; pipe: silver, length 10⅛ inches; netsuke: gold and pearl, diameter 1½ inches. Rogers Fund, 1914, 14.40.843

and mythology: fantastic animals predominated, like the *shishi* (the lion-dog), but animals of the zodiac were also popular. Heroes, reflecting Neo-Confucian virtues, were part of the figure repertory along with Buddhist and Taoist saints, whose pious feats appealed to the Japanese taste for the supernatural.

Toward the end of the century, new materials were in evidence, with stain and inlay used sparingly for dramatic effect. Coral, ranging in color from black to dark red, was employed principally for eyes, providing textural contrast and a reflective surface simulating "life," or vitality, as did the glass eyes inlaid in the large sculptures of the Kamakura period (1185–1333). Netsuke carvers began to sign their works, using art names rather than family names.

By the first half of the nineteenth century, as schools developed, pupils tended to carry on their masters' techniques and often copied their works. Skilled carvers sometimes published their designs as models or passed workbooks along to their more gifted apprentices. Subjects were increasingly drawn from printed sources, and this dependency may be responsible in part for the diminishing of much of the spontaneity and originality of the earlier pieces. To make their works distinctive, artists concentrated on refinements of technique. Netsuke became more ornate and more complicated, and portable ensembles became subjects for many beautiful *surimono* prints.

In subject, heroic legendary figures gave way to smaller, compact, and complex representations, especially those from Japanese folklore. Groups of figures—men and animals—were depicted, and portrayals became more naturalistic. Netsuke paralleled other artistic developments of the time. The introduction of such Western concepts as perspective had its effect on these small sculptures. The soft outlines hardened, and realism became the conventional style. Innovation was largely a matter of imaginative technique, an unusual subject, and a complicated decorative motif. If the eighteenth century represented the unrestrained beginnings of this art form, the first half of the nineteenth century shows it fully matured and highly sophisticated.

In 1853 Commodore Perry sailed into the harbor of Uraga, and in 1867 Japan's policy of isolation begun under Ieyasu was ended. As the country became Westernized, the daily wear of netsuke declined. Cigarettes came to replace the traditional small-bowl pipe and its accouterments, and suits with pockets grew popular with businessmen, who could still wear the kimono at home or for ceremonial occasions. The need for sagemono eventually vanished.

The opening of Japanese ports to foreign trade acquainted European collectors with netsuke, and their interest prompted a tremendous revival of this art form in Japan. Netsuke were produced in great numbers as souvenirs as well as art objects. From the 1870s through the 1890s major collections were formed in Europe. Unfortunately the majority of examples produced after the beginning of the Meiji Restoration (1868) were mechanical imitations of the earlier delightful sculptures, and are often angular and clumsy.

In general, Europeans tended to collect the earlier, more robust, and livelier

netsuke, while Americans, who for the most part did not come into contact with them until the twentieth century, were attracted to later pieces demonstrating technical achievement. Recently there has been a new surge of interest in these small sculptures in this country, and, stimulated by the publication of more reference material in English, Americans are building some of the best and most well-rounded collections in the world. The collection of The Metropolitan Museum of Art, reflecting as it does the tastes of its donors, who made most of their acquisitions during the late nineteenth and early twentieth centuries, is exceptionally strong in nineteenth-century examples. The pieces on the following pages have been chosen to present as broad a range as possible—in date, subject, and style. Together, these small sculptures, all of high quality, provide an introduction to the many forms of the netsuke carver's art, in all its intricacy, charm, and imagination.

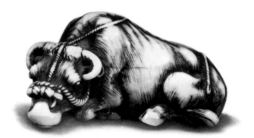

COLOR PLATES

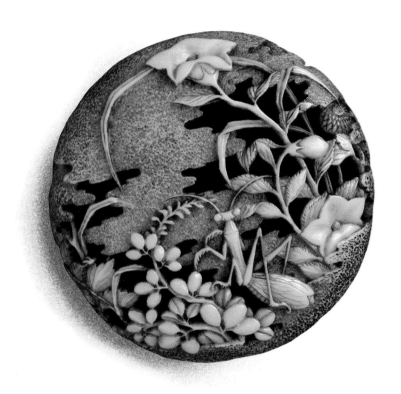

Still Life, no. 44

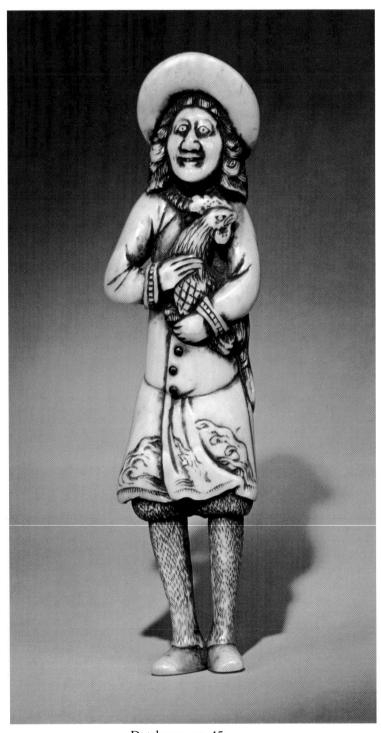

Dutchman, no. 15

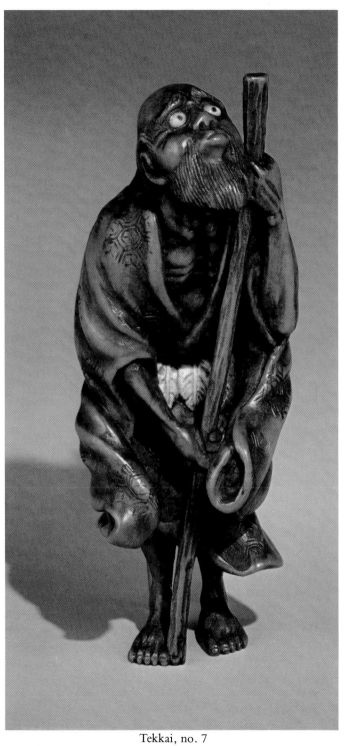

Tekkai, no. 7

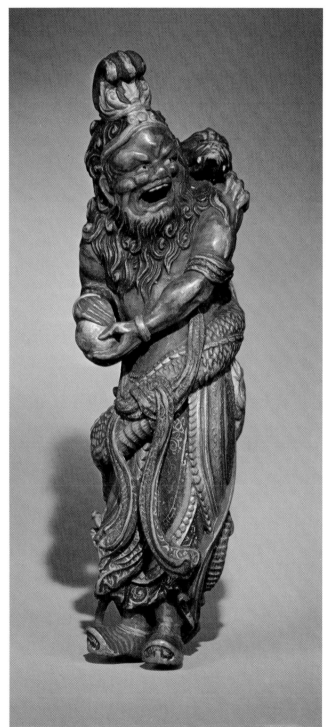

Ryūjin, no. 12

Hawk, no. 63

Octopus and Monkey, no. 60

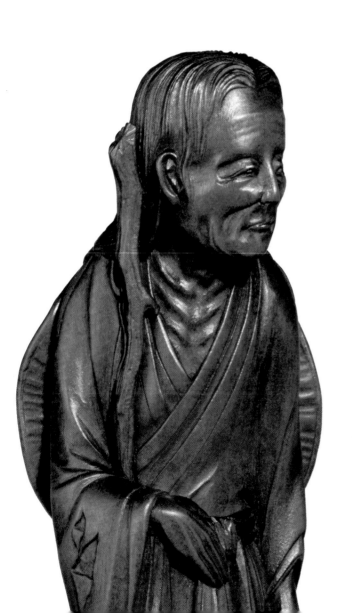

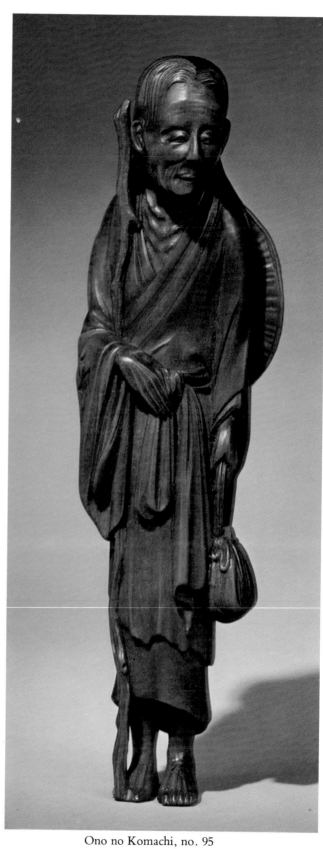

Ono no Komachi, no. 95

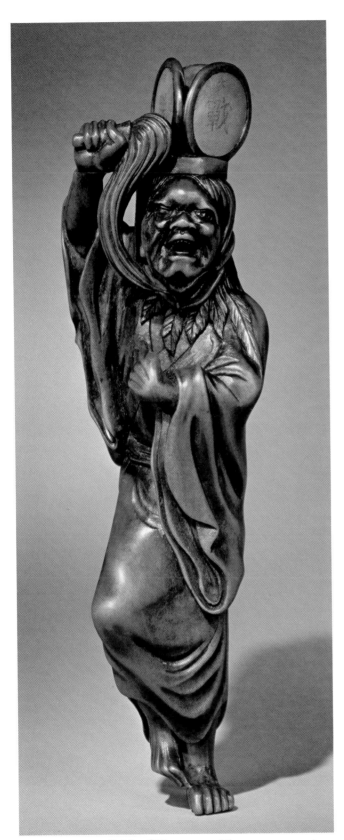

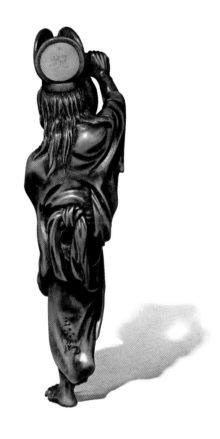

Spirit of Victory, no. 97

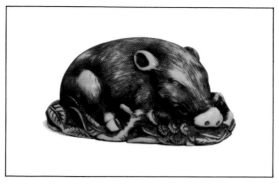

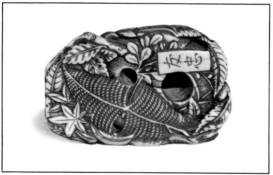

Boar, no. 42

CATALOGUE

Figural Netsuke of the Eighteenth Century

1. Kuan-yü

Many legends about the Han dynasty in China (206 B.C.–A.D. 220) tell of Kuan-yü (A.D. 162–220), one of three friends who had sworn an oath of brotherhood and who were renowned for their heroic struggles for justice. The trio included the famed Liu Pei, founder of the Shu Han dynasty (A.D. 221–64) of Szechwan. In one tale, Kuan-yü suffered a defeat in which he and two of Liu Pei's wives were captured. To protect his friend's wives from dishonor, he stood vigil outside their room during the night with his halberd in one hand and a lantern in the other. Through the centuries Kuan-yü's reputation grew until he was deified in 1594 as Kuan Ti, "Protector of the Realm." In Japan he represented the epitome of Confucian virtue and was a popular subject for Edo prints, paintings, and netsuke.

This tall, imposing figure communicates strength and purpose. The interpretation is characteristically Chinese in the slenderness of the face as well as in the style of the long, flowing robes. The undulating mandarin headdress blends into the softly contoured drapery of the outer robe, while the sleeve falls in gentle folds from the left arm.

Kuan-yü's elegantly formed hand, with its tapered fingers, caresses his beard, as if he were standing in quiet contemplation. His right arm holds his halberd behind him, further minimizing his martial character. This exquisite carving, enhanced by the patination of time and wear, is one of the finest eighteenth-century netsuke in the collection. (See no. 75, a later netsuke of Kuan-yü.)

Eighteenth century. Ivory, height 4⅞ inches. Signature undecipherable and added at later date. Gift of Mrs. Russell Sage, 1910, 10.211.1496

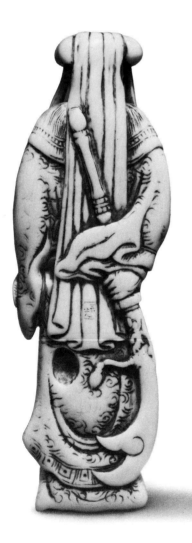

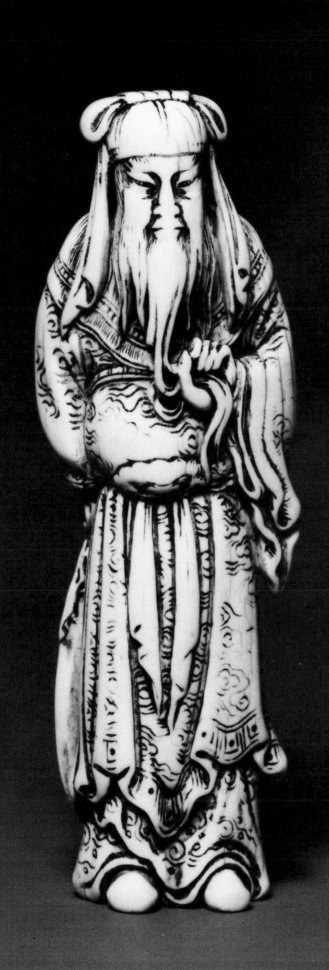

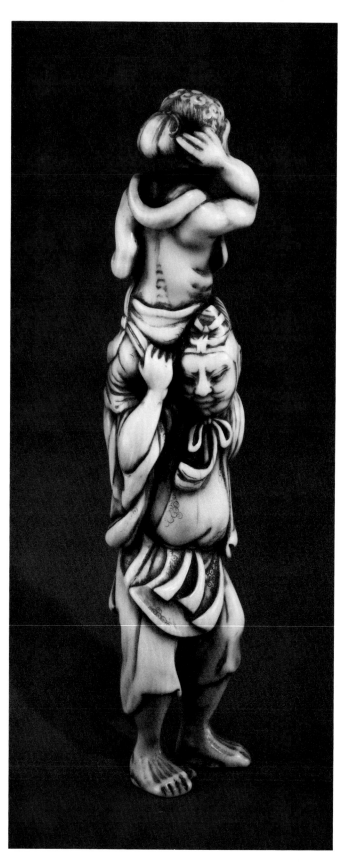

2. Omori Hikoshichi

Omori Hikoshichi (lived about 1340), a vassal of Shogun Ashikaga Takauji (1305–58), offered to assist a beautiful maiden on her way to a celebration of his victory over Emperor Go Daigo (reigned 1319–38). As he gallantly carried her across a stream, Omori glanced at her reflection in the water and saw that she had turned into a witch, whereupon he slew her with his sword. (In another account she is a general's daughter who is killed in battle while attempting to avenge her father's death. A Nō play, *Omori Hikoshichi* [1897], was based on this version.)

When viewed from various angles, the figure of the witch presents an unusual contrast.

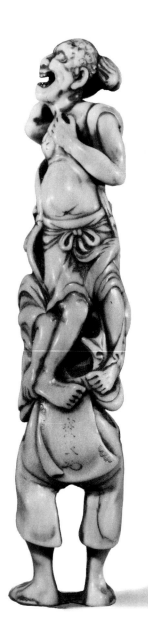

The back displays a hairstyle of topknot and curls, characteristic of early Buddhist sculpture, and the body is bare to the waist except for a narrow scarf, again reminiscent of images of holy men. However, the front view reveals a rather absurd female figure—trying modestly to cover herself—whose belly protrudes and whose bent legs cause her feet to turn in.

Tall and superbly carved, this piece expresses the vitality of early netsuke. To convey a sense of physical tension, the artist tilted Omori's body forward, flexed his knees, and depicted his toes grasping for balance. Because of its large size, fine quality, and humorous interpretation, this is the most unusual rendition of the subject shown.

Eighteenth century. Ivory, height 6 inches, Signed: Hōmin and a kakihan (stylized signature). Gift of Mrs. Russell Sage, 1910, 10.211.1502

3. Ashinaga and Tenaga

This netsuke is a variation on the legend of two symbiotic characters, Ashinaga ("Long Legs") and Tenaga ("Long Arms"). They cooperated in catching the fish that made up most of their diet: as Long Legs waded deeper and deeper into the water, where the fish were more abundant, Long Arms was able to reach down and seize them. The legend became popular in China and from there entered Japanese mythology. Here, the artist may have alluded to the source as he knew it by putting a Taoist sage in Chinese dress on Ashinaga's shoulder in place of Tenaga. The sage may be feeding Ashinaga advice rather than food.

This is the tallest piece in the collection and is representative of an early elongated style that lasted only a brief period, as this type of netsuke proved too clumsy for easy wear. Because of its shape, this netsuke may have been worn either thrust into the sash or, in the more usual way, held tight against the body by the cord passing through two openings on the sides.

Eighteenth century. Wood, height 6¾ inches. Gift of Mrs. Russell Sage, 1910, 10.211.2306

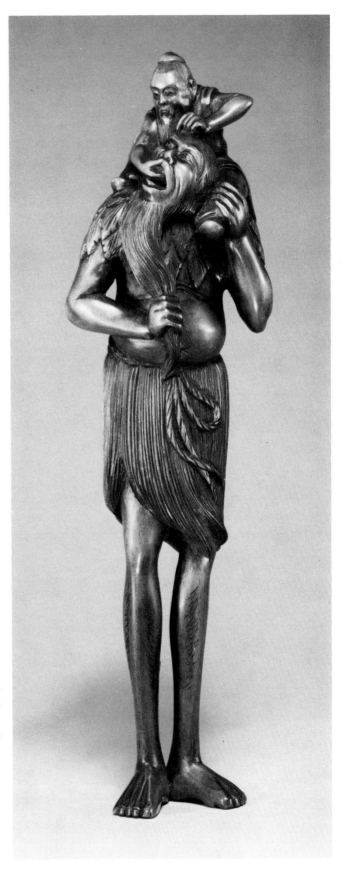

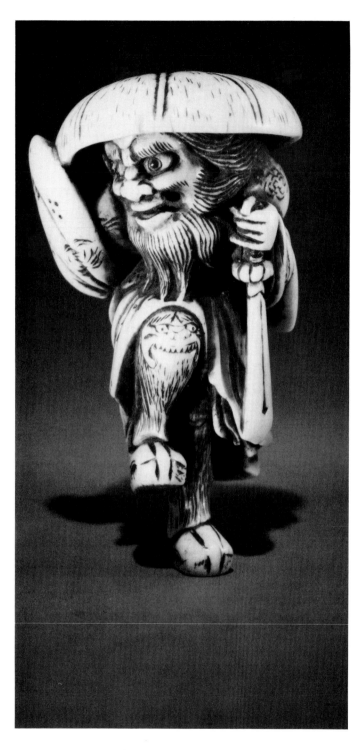

4. Shōki and Oni

Shōki, the demon-queller, is one of the most popular and humorous characters portrayed in netsuke. In Chinese legend, he was a student who failed the imperial examinations and committed suicide in shame. The emperor commanded that he be given an honorable burial, and in gratitude Shōki's spirit vowed to expel all demons from China forever. In Japan he is portrayed as a fierce hunter in martial garb, armed with a sword and wearing a wide-brimmed hat. He has a beard or whiskers, usually parted in the middle. The little demons he chases, called oni, usually get the better of him, clinging to him, tickling him, eating his hat, and in general causing great embarrassment to this towering figure of strength.

This is a typical eighteenth-century portrayal of Shōki and an oni in humorous contest. Balancing delicately on one foot, Shōki reaches around to dislodge the oni from his back, and his sleeve flies up as he grabs the oni's leg. Shoki's face is contorted with chagrin, while the oni, having torn two holes in his hat, clings tenaciously to him.

Eighteenth century. Ivory, height 2⅜ inches. Gift of Mrs. Russell Sage, 1910, 10.211.545

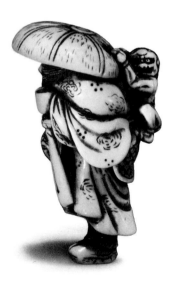

5. Sennin and Karashishi

Sennin were "immortals" thought to possess supernatural powers. In art they are frequently accompanied by a spirit, usually in the form of an animal, who attends or guards them. Chinese legends describe them as followers of Taoism, and in Japan the name "sennin" was sometimes applied to Buddhist monks who became mountain hermits. In netsuke they are characterized by curly hair and beards and large ears. They usually have a benign expression, and their Chinese-influenced costume includes a monk's garment, leaf girdle, and drinking gourd.

This sennin carries a karashishi (from the Japanese *kara,* or "China," and *shishi,* or "lion"), an animal of Buddhist origin (no. 19). The bond between the immortal and his companion is conveyed in the man's upturned smiling face. Western influence is apparent in his costume—the ruffed collar, tunic, leggings, and soft shoes—but the curly hair and beard, gourd, and Buddhist whisk under his sash (at the back), as well as the sacred animal, indicate beyond doubt that this example was not meant to portray a Westerner. Large, solidly proportioned figures such as this are representative of eighteenth-century netsuke.

Eighteenth century. Ivory, height 5 inches. Gift of Mrs. Russell Sage, 1910, 10.211.1498

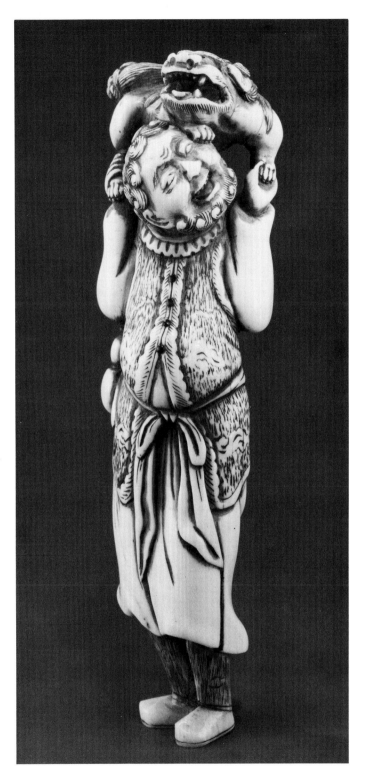

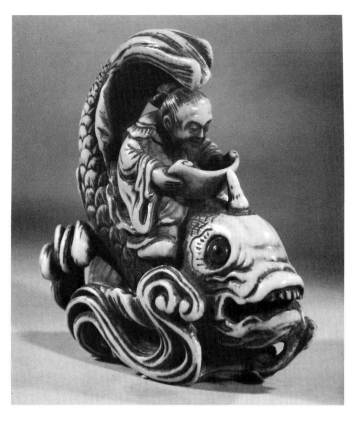

6. Kinkō

Kinkō (as he is known in Japanese) was a Chinese recluse (Ch'in Kao) who lived near a river. One day he was invited by the King of the Fishes into the river for a visit. Kinkō bade his pupils farewell and promised to return. After a month he reappeared astride a giant carp. According to a Japanese version of this legend, he then instructed his pupils not to kill fish and returned forever to the underwater domain.

This sennin, in a scholar's robe and reading from a scroll — perhaps an admonishment against the killing of fish — suits one Japanese version of the story, but the carp's horn, an unusual detail, suggests another in which a sennin nurtured a large carp that grew horns and wings. Eighteenth-century carvers often combined details from several similar legends. To them, variation and creativity frequently meant more than adherence to a specific iconography.

Here, the carp's tail arches protectively over the sennin, while the horn projects upward, focusing the viewer's attention on the small figure. The waves cradle the rider and mount and seem to be bearing them to their destination. The carp's eyes, of tortoiseshell with inlays of black coral, add contrast and color to the design.

Eighteenth century. Ivory, height 2 inches. The H. O. Havemeyer Collection, Bequest of Mrs. H. O. Havemeyer, 1929, 29.100.756

7. Tekkai

Tekkai, a Taoist immortal, blew his soul to heaven. But on the soul's return it could not find its body and had to enter that of an old man. In this portrayal in wood, the face is given great expressiveness through the large ivory eyes, accented by black-coral pupils. The lifelike quality of the sculpture is enhanced by the tilt of the head, puckered lips, and curve of the body, which has a sharply defined neck and chest. Tension within the sculpture is further heightened by the action of an unseen wind whipping the tattered robe against the straining body.

A leaf girdle of ivory and tortoiseshell hugs the body at the hips and flows smoothly into

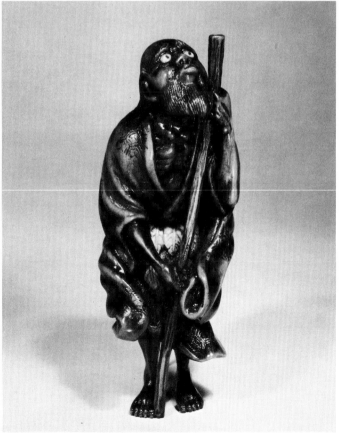

the lines of the robe. The inlay adds color and provides textural contrast with the softly contoured wood. Hanging from the rear of the sash, attached to a malachite flower-shaped netsuke, is a movable ivory drinking gourd.

Late eighteenth–early nineteenth century. Wood, height 2¾ inches. Signed: Chikusai. Gift of Mrs. Russell Sage, 1910, 10.211.2362

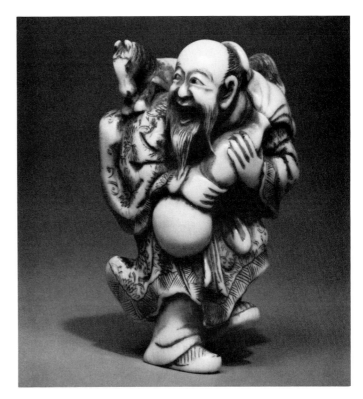

8. The Chōkarō Sennin

The Chōkarō (Chinese: Chang Kuo-lao) sennin was said to have a magical gourd from which he was able to conjure a mule by spitting or spilling water on the gourd's surface. This mount, which needed neither food nor water, could travel unlimited distances without tiring and would vanish into the gourd on command.

This netsuke shows the mule issuing from the gourd—or perhaps returning to its unusual container. The carving conveys a real feeling of motion and is spiced with lively humor.

Late eighteenth–early nineteenth century. Ivory, height 2¼ inches. Signed: Yoshitomo. Gift of Mrs. Russell Sage, 1910, 10.211.284

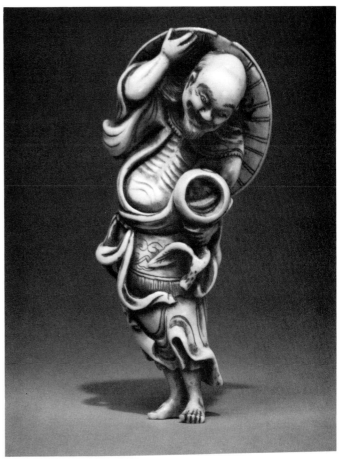

9. The Tōbōsaku Sennin

The peach was the emblem of immortality in both Chinese and Japanese myths. This smiling, elderly sage is holding the peach of immortality, which is attached to a long stem rooted near his foot. The fruit has been cut open to reveal a tiny seated figure reading a scroll. This is a direct reference to the semilegendary scholar Tōbōsaku (Chinese: Tung-fang Shuo, 160 B.C.–?), who was a retainer of the Han emperor Wu Ti (reigned 140–87 B.C.). Legend tells that this scholar-poet stole three of the peaches of immortality, which ripen only once every 3,000 years, and ate them, thereby ensuring his longevity. The scroll alludes to his poetry and learning.

Late eighteenth–early nineteenth century. Ivory, height 3³/₁₆ inches. Signed: Chikaminsai. Gift of Mrs. Russell Sage, 1910, 10.211.1441

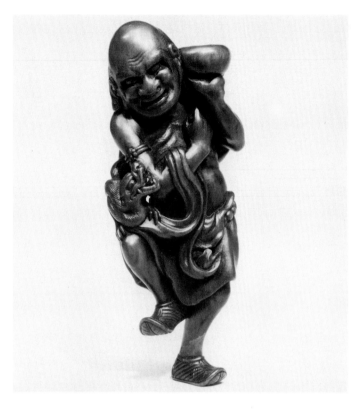

10. The Handaka Sonja

Rakan (Chinese: lohan) differ from sennin in that they are derived from Indian Buddhist legend rather than Chinese Taoism, and their severe, clean-shaven faces reflect this heritage. Their appearance is characterized by shaven heads, long eyebrows emphasizing their scowling features, and long ears, in one of which is an earring. Their costume is usually that favored by Indian ascetics — the dhoti, a long loincloth, whose end is draped about the upper body. (The dhoti is also seen on figures of Japanese Buddhist sculpture.)

As a rakan, the Handaka Sonja is one of the sixteen (eighteen in China) specially chosen followers of the Shakyamuni Buddha. This particular figure is usually shown carrying a bowl from which a dragon issues in a cloud of smoke.

This netsuke and no. 9 were made by the same artist. Although the same height, they were carved in different mediums, and it is of interest to contrast their styles and signatures. The sennin netsuke is rather whimsical as befits the subject, and it is carved in ivory, a substance imported from China. The signature is in *soshō*, the running script style used on less formal occasions and for poetry. The Handaka Sonja is carved from wood, the traditional medium of Buddhist sculpture. This material was cut and dried with ritualistic ceremony, and it held a special, sacred meaning for the carver. The signature on this netsuke is in exquisite *kaishō,* the formal script of Chinese characters adapted to the Japanese language, and the artist has given his full name (probably an art name).

Late eighteenth–early nineteenth century. Wood, height 3³⁄₁₆ inches. Signed: Sadahiro Chikaminsai and a kakihan (stylized signature). Gift of Mrs. Russell Sage, 1910, 10.211.2343

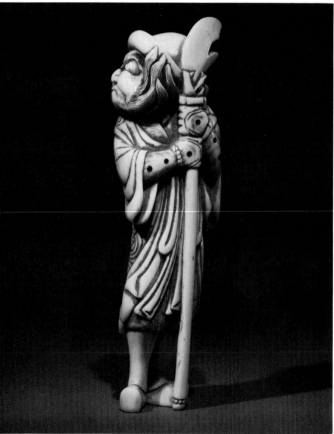

11. Guardian Figure

This guardian figure combines the physical attributes of several legendary and historical characters. Such confusion is not unusual in eighteenth-century carvings; most craftsmen of this period created their designs more from memory and imagination than from a codified iconography.

The fierce countenance and flowing beard are those of Shōki (no. 4). The halberd is that of Kuan-yü (no. 1), while the figure's hat, robe, knickers, leggings, and shoes are those of a Dutchman (no. 15). These features have

been combined successfully into a strong composition, and the mélange of elements in this netsuke is characteristic of the freedom of expression often found in the eighteenth-century carvings. By the end of the century, however, interpretations of legends had become more formalized.

Eighteenth century. Ivory, height 4⅝ inches. Gift of Mrs. Russell Sage, 1910, 10.211.1504

12. Ryūjin

Ryūjin, the Dragon King of the Sea, probably came into Japanese folklore from China. He is a popular figure in netsuke, usually shown as a fierce old man, with a long curling beard, and accompanied by a dragon. Here, he holds the jewel by which he controls the tides.

This example is in the style of Yoshimura Shūzan of Osaka, a Kanō-school painter of the mid-eighteenth century, who, according to the *Sōken Kishō,* was considered one of the finest carvers of his day. He is the innovator in netsuke of legendary and mythological figures done in this technique: the carved wood was covered with a gessolike sealer over which watercolor was applied.

Although this sculpture is in Shūzan's style, it is boxwood rather than the softer, more open-grained cypress that he favored, suggesting that it was not carved by the master himself. Its freshness of color is the result of applying oxidized copper and other minerals in a solution of glue. Ryūjin's garment is ornamented with a design in gold lacquer, simulating patterns often found on the robes of Buddhist sculptures.

This is an exceptional carving, with man and beast represented in a close relationship. The artist has communicated their dependence by carving parts of the dragon's body under the king's garments, implying that man and dragon are one. (See no. 73, a later netsuke of Ryūjin.)

Late eighteenth–early nineteenth century. Wood, height 4 inches. Gift of Mrs. Russell Sage, 1910, 10.211.2331

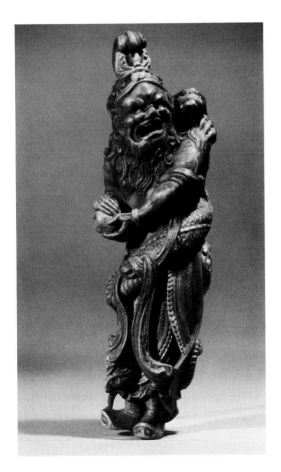
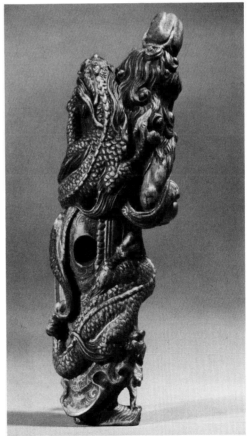

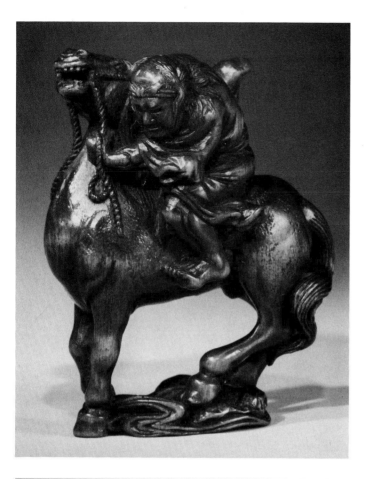

13. Warrior Astride Horse

This netsuke may portray the samurai Shiganosuke. In 1582 the warlord Oda Nobunaga (1534–82) was assassinated by Shiganosuke's uncle, a traitorous general. Not wishing to fight his kinsman, Shiganosuke rode into a lake in full armor in order to avoid battle. In this netsuke the horse seems to be refusing to enter the water, while the samurai seems determined to go on.

The carving of the horse's body, with its powerful chest, neck, and head, captures the stubborn strength of the animal as it strains against its master's prodding. The warrior's face is fiercely determined as he pulls on the reins, forcing the horse's mouth open and exposing its teeth and tongue. While the netsuke captures the horse and rider in a moment of intense conflict, its compact design emphasizes their basic unity.

Late eighteenth century. Wood, height 2⅛ inches. Gift of Mrs. Russell Sage, 1910, 10.211.2299

14. Sleeping Farmer

Many unsigned carvings from the eighteenth century appear simple in form but are actually complicated works of art. This figure of a sleeping farmer on a large, folded leaf, which substitutes for a mat, is an example of this type. The exposed leg and feet are simply finished yet well formed and proportioned, and the doubled-back leaf with its veins and jagged edges is carved in a rather plain manner. The technical skill of the artist is apparent, however, in the well-defined small scythe at the farmer's waist and in the twisted loops of the cord which serves as a sash.

The cord openings underneath are typical of the eighteenth-century style, in which the purpose was to hide the knot that keeps the netsuke tied to the ensemble. In the nineteenth century these openings became smaller and the knot more conspicuous.

Eighteenth century. Wood, length 1⅜ inches. Gift of Mrs. Russell Sage, 1910, 10.211.2188

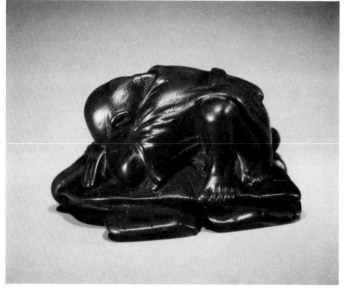

15. Dutchman

Among the few foreigners allowed to remain after the Tokugawa government banned Christianity and expelled the Portuguese in 1638 were the Dutch, who were confined to the island of Deshima in Nagasaki Harbor. Only the representative of the Dutch East India Company was permitted to travel to the mainland to give his yearly report. By the second half of the eighteenth century, when some of the restrictions had been lifted, there was a revival of foreign studies, and in 1789 the first Dutch-language school opened in Edo. It seems likely, therefore, that netsuke of Dutchmen date from about the last quarter of the century. Their popularity was short-lived, however, as they went out of fashion around the first quarter of the nineteenth century.

Since few Japanese had actually seen a foreigner, genuine portraits are rare, and a type of Dutchman developed in netsuke that is exemplified by this representation. Round-eyed, with a bulbous nose and shoulder-length hair, he wears a tasseled, brimmed hat, buttoned tunic with ruffed collar, knee breeches, stockings, and plain soft shoes. Most of the figures carry a dog, gun, or bird—usually a cock, as here, probably referring to the Dutch colony's pastime of cockfighting. Many of these netsuke are ivory, possibly because they would appeal to the wealthier and more worldly clients who could afford that material.

Late eighteenth century. Ivory, height 4⅛ inches. Gift of Mrs. Russell Sage, 1910, 10.211.1506

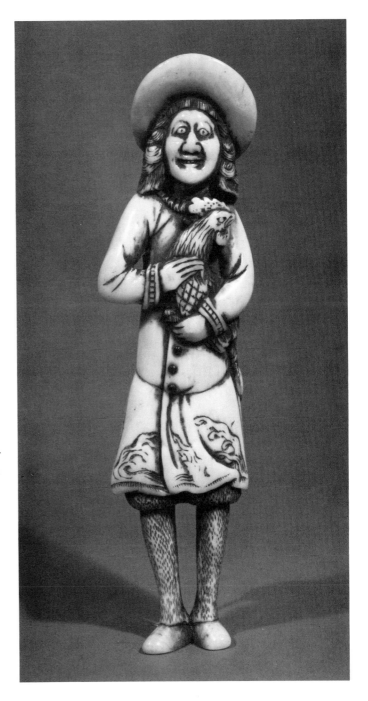

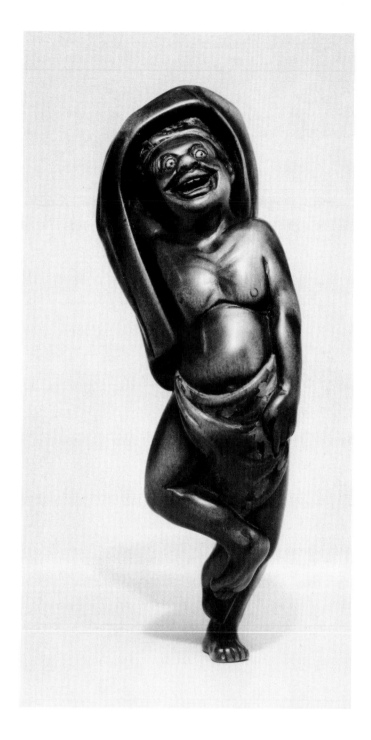

16. South Sea Islander

The Japanese had traveled to the South Sea Islands prior to 1639, but by the time this netsuke was carved, overseas travel had been banned for more than a century. Therefore this piece, carved in boxwood, was based on earlier descriptions or, more probably, copied from a Dutch book. The figure itself is high-spirited and humorous and is free of the heavy satirical tone often found in later portrayals of this subject. The touches of red on the islander's loincloth are watercolor applied directly to the base wood without a primer of gesso. As a result, the color has almost completely flaked off. The back of the islander's shield is inlaid with pieces of ivory to suggest a grotesque mask whose imagery was used to frighten the enemy.

Most nineteenth-century renditions of South Sea islanders were carved from ebony, and the figures usually clutch large pieces of coral in their arms.

Eighteenth century. Wood, height 3¾ inches. Gift of Mrs. Russell Sage, 1910, 10.211.2335

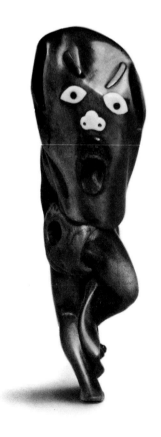

17. A Summer Landscape

This lacquer netsuke was made to match an inrō of the same material. Its base was carved from a light wood, probably cypress, which is porous and provides a good surface for the application of lacquer. In a uniquely Japanese technique known as a *maki-e*, literally "sprinkled picture," clear lacquer is applied and minute gold flakes are sprinkled onto it when it is still tacky. Here various techniques were first used in building up the upper parts, before the artist completed the lacquering and added cut gold for further embellishment, while the back has a thin, even coat of sprinkled gold. This piece has a metal ring attached to its underside through which the cord is threaded and knotted.

Eighteenth century. Lacquered wood, height 1¾ inches. Signed: Koma Koryū. Bequest of Stephen Whitney Phoenix, 1881, 81.1.304

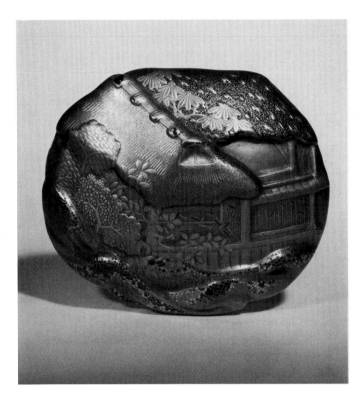

18. Snowpeas

Little escaped the attention of the netsuke carver, not even the smallest blade of grass or a cluster of snowpeas. Here the artist has captured the simplicity, grace, and fluid form of the vegetable by emphasizing the gentle swelling contours of the tiny peas within the pods. Light staining, which was applied to all the surfaces and then polished, increases the shadowy effect of the cluster.

Eighteenth century. Ivory, height 2¼ inches. Signed: Okatomo. Gift of Mrs. Russell Sage, 1910, 10.211.1154

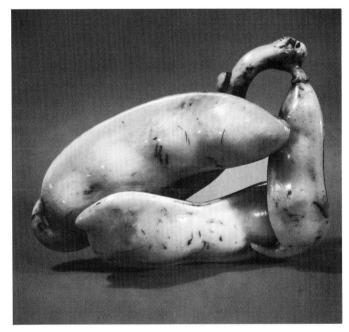

Early Animal Imagery

19. Karashishi

The karashishi is characterized by a fierce expression with protruding eyes, wide nostrils, and open mouth. Its curly mane is usually balanced by long curled locks on its legs and a bushy tail. The earlier the rendition, the stronger the facial expression and the more elaborate the curls. In China karashishi are shown in pairs and are commonly associated with the imperial family; in Japan they are often found in Buddhist lore, occasionally as temple guardians, and are sometimes associated with holy men (no. 5). In netsuke, karashishi are frequently depicted whimsically.

This chunky and compact netsuke depicts the animal scratching its ear, and the artist uses the spherical shape most characteristic of a well-conceived animal netsuke. Here the facial expression is emphasized by deep-set eyes and open jaws. The cavernous mouth, created by deep undercutting, provides a dark contrast to the strong, sharp white teeth. The massive body has a visible bony spine formation and powerful haunches. As it is unusually bulky, this netsuke may have been worn by a large man.

Early–middle eighteenth century. Ivory, height 2 inches. The H. O. Havemeyer Collection, Bequest of Mrs. H. O. Havemeyer, 1929, 29.100.12

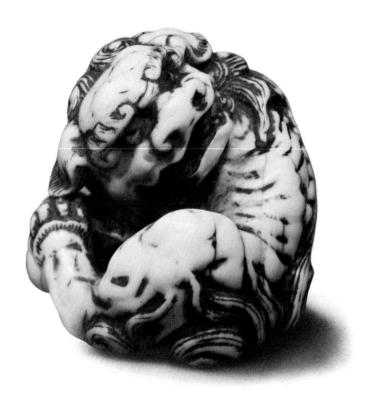

20. Shishi

This ridiculous-looking shishi is portrayed in an amusing and playful position. The crossed eyes and open-mouthed grin are, no doubt, a deliberate parody, as its sardonic features are grotesquely humanoid. This interpretation conveys a doglike friendliness rather than the fierceness usually associated with this animal. The exceptionally large cord openings, the color of the patina, and the humor of the exaggerated features contribute to the devilish charm of the piece and are indications of its date.

Mid-eighteenth century. Ivory, length 2¼ inches. Gift of Mrs. Russell Sage, 1910, 10.211.1098

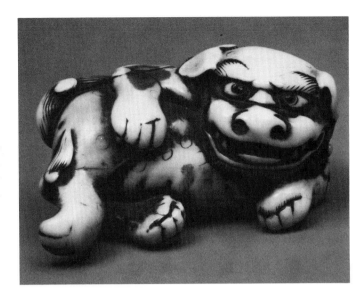

21. Resting Shishi

Two elements help date this netsuke: its size and, more important, its carefully detailed male sexual organs. Not until the late eighteenth century did animal netsuke display genitalia, but from that time on, the vast majority have clearly defined male characteristics. Carvings of males and females in couples were rare, and femininity was only alluded to in the depiction of motherhood. This was in keeping with the subservient position Neo-Confucian thought accorded to women.

This softly contoured sculpture is more a gentle cat than a lion. The dark inlaid pupils are set dramatically into gold eye sockets. This contrast adds alertness to the facial expression and indicates the wealth of the owner, while circumventing government sumptuary laws. The deep yellow-orange of the stomach with its heavy patination is an indication of age and wear. After the early nineteenth century, representations of shishi went out of style.

Late eighteenth–early nineteenth century. Ivory, length 1⅝ inches. Signed: Hisamasa. Gift of Mrs. Russell Sage, 1910, 10.211.17

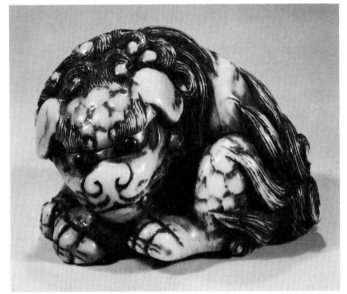

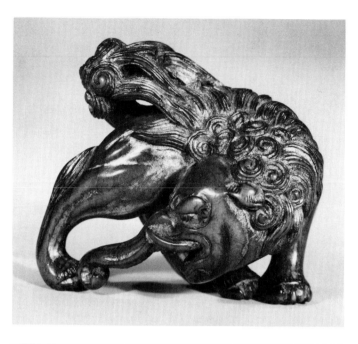

22. Crouching Baku

The baku is supposed to eat bad dreams. It is so effective that even the character for "baku" painted on a headrest will keep away frightening nightmares. Physically it combines the head of an elephant and the body, mane, claws, and tail of a karashishi. The Japanese version differs slightly from the Chinese, which has the tail of an ox and a spotted hide. Fantastic composite animals like the baku and kirin went out of style by the end of the eighteenth century.

This is a rare example, depicted not in the usual seated position but crouching as if searching for something, and carved in wood rather than the ivory used for most early mythological animals. The finish is enhanced by contrasting gold lacquer applied to the surface.

Eighteenth century. Wood, length 2 inches. Signed: Sadatake or Jōbu. Gift of Mrs. Russell Sage, 1910, 10.211.2278

23. Seated Baku

All wonderful curls and curves, this piece is among the finest netsuke in the collection. An S shape flows gracefully from the upraised head with its short, twisting trunk down through the curving neck and body, and then continues into well-proportioned legs and haunches. Tusks hug the top of the trunk, framing the small, shiny, black inlaid eyes. The baku's tail is composed of several curls from which long tendrils shoot up toward the lower jaw. Similar shell-shaped curls line the lower jaw, and flowing tendrils create a sweeping curve from jaw to tail. The body surface is covered with slightly rounded protuberances which indicate fleshy, muscular areas and which are found only on eighteenth-century representations of supernatural animals. Additional flamelike projections heighten the feeling of movement. The humorous, effervescent quality of the carving captures the bizarre nature of the animal.

Eighteenth century. Ivory, height 2⅞ inches. Gift of Mrs. Russell Sage, 1910, 10.211.1105

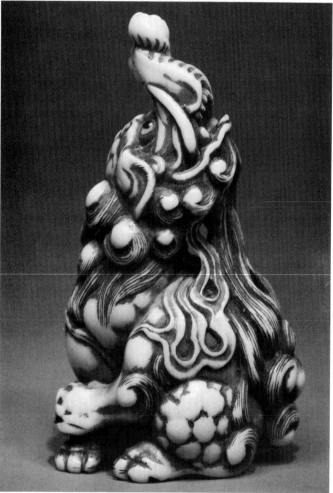

24. Kirin

The kirin, the Oriental version of the unicorn, is considered a paragon of virtue: so light-footed that it moves without noise and so caring that it harms not even the smallest insect. Its rare appearance on earth is thought to be a lucky omen.

The kirin has the head of a dragon, the body of a deer, legs and hooves similar to those of a horse, and the tail of a lion. Its horn lies against the back of its head. Scales or protuberances are part of the body decoration, and flamelike shapes usually flare from the chest or shoulders. These "fire markings" are a design element that originated in Chinese art and were used by netsuke carvers only during the eighteenth century to indicate that the subject was a mythological beast with supernatural characteristics. The general composition of this piece is very similar to that of no. 23, and both may be by the same sculptor.

Eighteenth century. Ivory, height 2⅞ inches. Gift of Mrs. Russell Sage, 1910, 10.211.1408

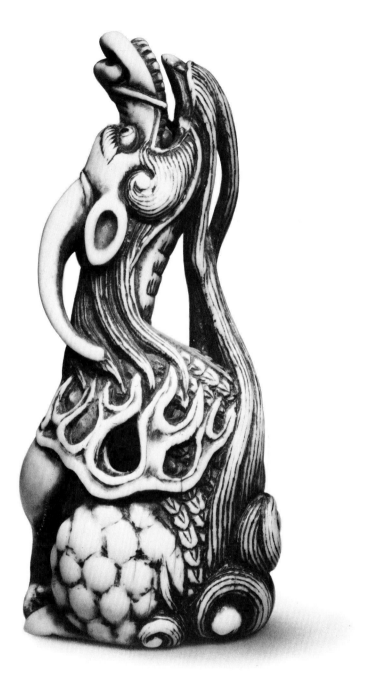

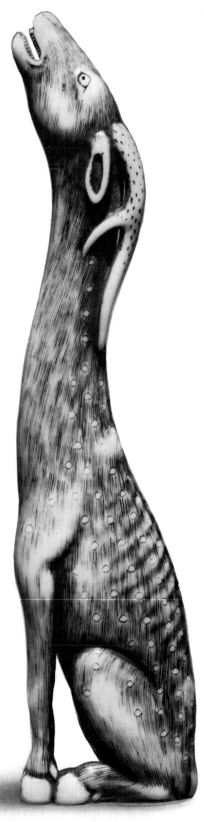

25. Stag

This stag represents the stylistic transition between the highly imaginative creatures of the early to middle eighteenth century and the more realistic animals of the nineteenth century. Its elegantly simple pose—seated, with upturned head and extended neck—is similar to those of kirin in earlier netsuke, but its branched antlers, sloping ribs, and spotted coat are indications of a new interest in realistic details.

Late eighteenth century. Ivory, height 5¼ inches. Gift of Mrs. Russell Sage, 1910, 10.211.2308

26. Tanuki

The tanuki, a badgerlike animal that is a member of the raccoon family, was portrayed as a partially imaginary beast endowed with supernatural powers. Depicted more as a practical joker than a malicious or evil character, it often assumed disguises to further its subterfuges. Here it wears a lotus-leaf hat, carries a bottle of sake in one hand, and holds a bill of sale for the liquor in the other. While the bottle and the bill suggest drunkenness, the lotus leaf, symbolizing purity, alludes to Buddhism, with its emphasis on sobriety. This netsuke might be taken as a comment on the priests of the time, who sometimes indulged in practices contrary to their religious vows.

Garaku, the artist, is mentioned in the *Sōken Kishō* as "a clever carver and a disciple of Tawarya Denbei," an early master whose works have not survived. The few authentic netsuke by Garaku are highly imaginative and expressive, as is this one, and frequently communicate the same feeling of humor.

Eighteenth century. Ivory, height 2¾ inches. Signed: Garaku. Gift of Mrs. Russell Sage, 1910, 10.211.1436

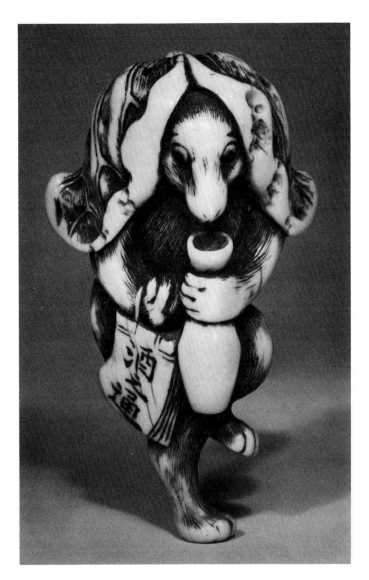

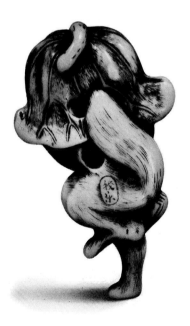

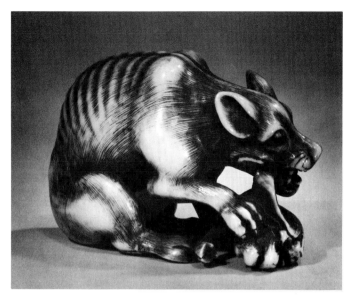

27. Wolf

Eighteenth-century animal netsuke by artists in the Kyoto area had well-defined spines and rib cages, and if the creature had a tail, it was usually tucked between the legs and hidden under the body. (During the nineteenth century, the tails of animal netsuke were incorporated on the outside of the piece, usually wrapped around the body.) On the basis of these features alone, this wolf can be attributed to a Kyoto artist of the eighteenth century, a date verified by the signature of Tomotada, who is listed in the *Sōken Kishō* and probably worked in Kyoto in the second half of the century.

The gaunt figure may represent hunger, or it may be a symbolic expression of anger against the poor crops, high taxes, and capricious samurai overlords of the time.

Eighteenth century. Ivory, length 2 inches. Signed: Tomotada. The H. O. Havemeyer Collection, Bequest of Mrs. H. O. Havemeyer, 1929, 29.100.918

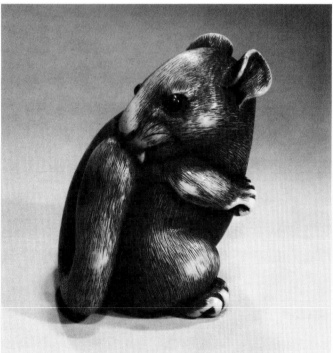

28. Squirrel

The most noticeable change in animal netsuke of the late eighteenth century is the use of realistic or active poses rather than the more static, "at rest" ones that had been common from the mid-eighteenth century. The twisted pose of this squirrel succeeds in capturing the animal's nervous quality. The black-coral eyes protrude and the ears and paws are extended, but the composition still retains its compact form. The squirrel's chubby legs and tiny, clenched paws make it a very appealing figure.

Late eighteenth century. Ivory, height 1½ inches. Gift of Mrs. Russell Sage, 1910, 10.211.52

29. Dog

The ribs of this animal are prominent, but this is probably a stylistic characteristic of the artist rather than an indication of the animal's hunger (although both interpretations are possible). The figure's full face with its short muzzle and square jaw, as well as its thick neck and broad chest, make it clear that this is a dog rather than a wolf (no. 27). The curve of the body and neck flows to the ears, which are cocked forward, creating a smooth, continuous line.

This carving is a classic example of what is termed "Kyoto style," a phrase applied to animal netsuke made by three (or more) artists who worked in Kyoto in the eighteenth century and who are named in the *Sōken Kishō*. Of the three—Masanao, Okatomo (no. 18), and Tomotada—Tomotada seems to have been the most prolific, and enough of his work has survived to establish criteria for judgment of the stylistic features which are also common to the other two. Some characteristics of this artist have already been mentioned (no. 27). In addition, an animal by Tomotada usually has an open mouth, showing sharply defined teeth and deep hollowing of the oral cavity, which provide great contrast between dark and light areas of the sculpture. Most of Tomotada's netsuke have natural openings through which the cord could be threaded; he did, however, often add holes to improve the balance of the netsuke on the sash. Netsuke depicting animals of the zodiac were in great demand, and Tomotada did some of his best work in this genre (nos. 32, 37, 41, and 42).

Eighteenth century. Ivory, height 2½ inches. Signed: Tomotada. Gift of Mrs. Russell Sage, 1910, 10.211.1106

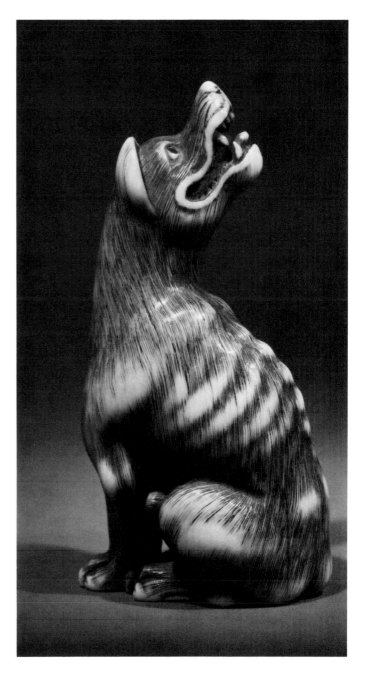

Animals of the Zodiac

WHILE IN THE WEST zodiac representations are based on the twelve months of the year, the Oriental zodiac uses a cycle of twelve years. It is said that Buddha once called all the animals to him for a celebration, but only twelve came. These animals' places in the zodiac were determined by the order in which they arrived. Each is associated with a specific animal, and it is thought that a person shares, to some extent, the traits of the animal during whose year he or she was born. The zodiac animals also represent hours of the day and directions on the compass.

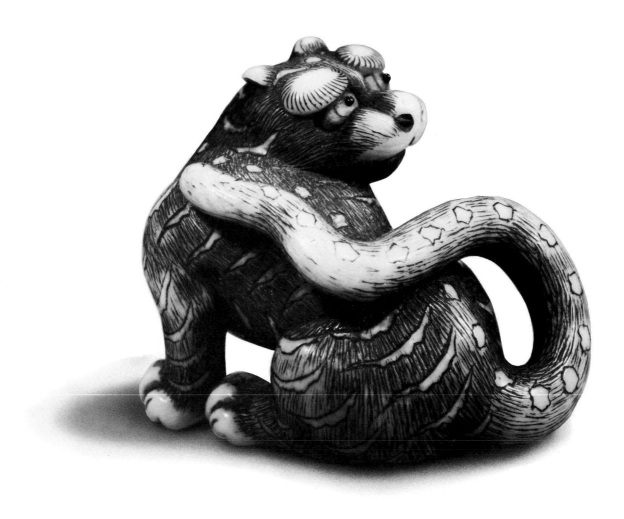

30. Tiger

Tigers are not native to Japan, but their ferocity and strength made them favorite subjects in Japanese art of the Edo period. Tiger netsuke are usually carved in a crouching position, the head turned into the curve of the body. Although this feline, with its beetle-brow and mournful eyes, seems like a household pet, its strength is suggested in its haunches and well-padded paws.

Nothing is known about the artist, Raku, but his name appears in a jagged reserve, as it does here, on a number of similar tigers.

Tiger people are known to be wary and suspicious, yet it is considered lucky for a male to be born in this year, as the animal represents worldly power. This association probably accounts for its popularity in netsuke form.

Late eighteenth century. Ivory, height 1⅜ inches. Signed: Raku. Gift of Mrs. Russell Sage, 1910, 10.211.1099

31. Rat and Offspring

According to tradition, the first animal to respond to Buddha's call was the rat. Therefore, it is usually portrayed as a soft, mild creature. In this netsuke, the rat's gentleness is emphasized by the presence of tiny offspring. The disproportionately large head and big black inset eyes of almost luminous quality are typical of early rat carvings. This netsuke was probably worn by someone born in the year of the rat, or it may have served as a talisman for averting evil and attracting prosperity, properties associated with rat netsuke. People born in this year are thrifty in nature but are generous to those they love.

Eighteenth century. Ivory, height 1⅞ inches. Bequest of Stephen Whitney Phoenix, 1881, 81.1.34

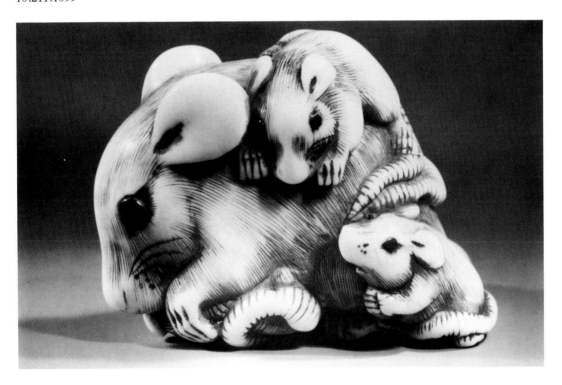

32. Reclining Ox

The *Sōken Kishō* states that "Tomotada's work is as highly prized in the *Kanto* area [Tokyo] as in his home town of Kyoto. For this reason many, many copies were made. He is a great carver, especially of cattle." There are hundreds of netsuke signed Tomotada, many of which are of oxen. Of these, however, only a small number were made by him.

Several traits characterize a genuine Tomotada ox. The softly rounded snout is always double-haltered. Even more important, the bulging eye sockets start at the crown of the forehead and extend toward the sides to end in open, staring eyes with inlaid pupils of black coral. The body is heavy and ponderous. Viewed from the top, the belly bulges from either side. From underneath, the wattle of the chin flows toward the clearly defined male genitalia. The underbelly bears the signature in reserve as well as the cord openings, which are of unequal size.

The ox's hooves are clearly defined, and the bone structure is of realistic proportions. The halter rope is meticulously carved in relief (*ukebori*) and thus always protrudes above the surface of the body. An authentic Tomotada is an exciting sculpture.

Those born in the year of the ox are said to be as patient as their sign but also are remarkably stubborn, and dislike failing at anything they attempt.

Eighteenth century. Ivory, height 2½ inches. Signed: Tomotada. Bequest of Stephen Whitney Phoenix, 1881, 81.1.40

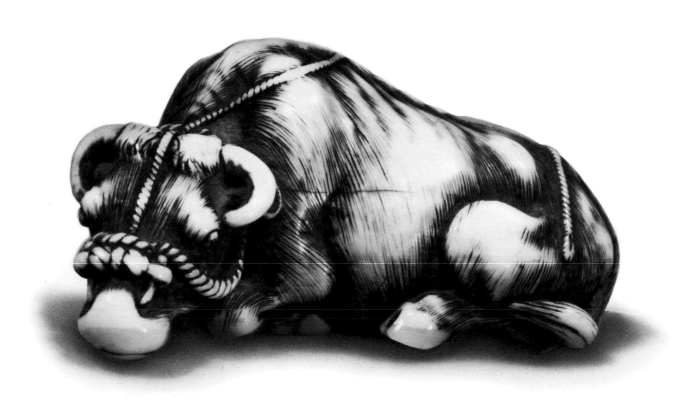

33. Tiger

This netsuke was carved by Minkō, an eighteenth-century artist noted for the originality of his designs. The *Sōken Kishō* shows an example of his kakihan (stylized initials or signature) and states that he lived from 1735 to 1816. It also relates that he resided in the capital of Ise (now Mie) Province, that he carved in wood, using a variety of techniques, and that his works were very popular and widely imitated.

Minkō's style is unmistakable. To attain a "bright-eyed" look in the eyes of his animals, he used brass inlays in which shiny black-coral pupils were set. Influenced by theatrical design, Minkō was the first netsuke artist to use metal inlays for the formation of eyes, a technique borrowed from the Nō mask. He was also the first to add a red stain to the eyes, nostrils, and mouths of his figures, thus mimicking the Kabuki makeup.

The body of the animal is stained a shade of brown most associated with Minkō's works. The dark striping pattern emphasizes the contour of the form. Most notable, however, is the formation of the feet. Minkō's tigers all have large, well-defined, padded paws with claws that curve around the front of the toes. He added a red stain to the mouth, sometimes inside the nostrils, and always to the signature, although most of this coloring has disappeared with time and handling.

Eighteenth century. Wood, length 1⅝ inches. Signed: Minkō and a kakihan (stylized signature). Gift of Mrs. Russell Sage, 1910, 10.211.1981

34. Hare

Legend says that the hare performs the task of keeping the moon clean. The moon hare, a Japanese "man in the moon," is said to live a long time and to turn white with advanced age. This netsuke, with its broad chest and powerful body, conveys the spirit of an animal prepared for instant flight.

Considered basically placid in temperament, people born in the year of the rabbit are easily thrown into a melancholy state. They are tactful and, though conservative in nature, make good gamblers because of their reliance on intuition.

Nineteenth century. Wood, height 2⅛ inches. The Edward C. Moore Collection, Bequest of Edward C. Moore, 1891, 91.1.988

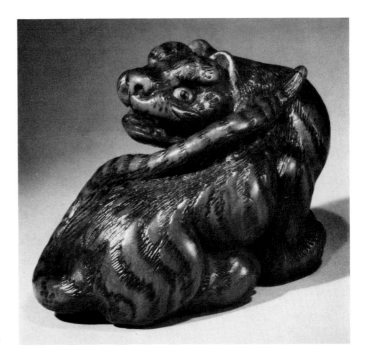

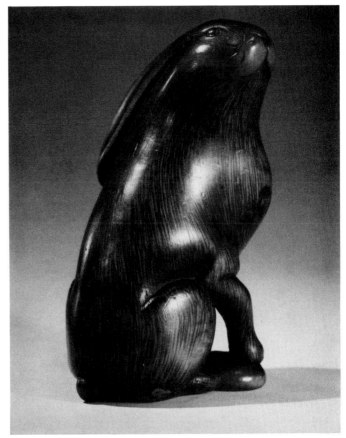

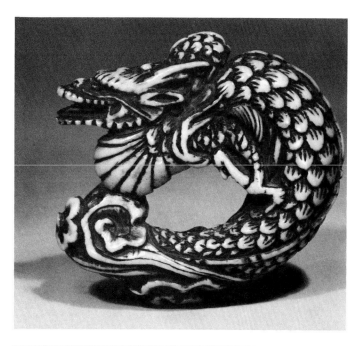

35. Dragon

The dragon is the only mythical beast included in the zodiac. The traditional Japanese interpretation has a flat head with two horns extending down its back, long whiskers, a scaly, snakelike body with spines on its back, and three-clawed feet (the Chinese imperial dragon has five-clawed feet). It is said to embody both male and female characteristics and has unlimited powers of adaptation. This one is unusual, as it seems to be based on the seventeenth-century doughnut-shaped style of netsuke. Continuous wear has worn an indentation on the inside curve of the tail area.

Hard-working and sincere, people born in the year of the dragon are known for their energy. Easily excitable, they are, however, trustworthy.

Eighteenth century. Ivory, height 1¾ inches. The H. O. Havemeyer Collection, Bequest of Mrs. H. O. Havemeyer, 1929, 29.100.787

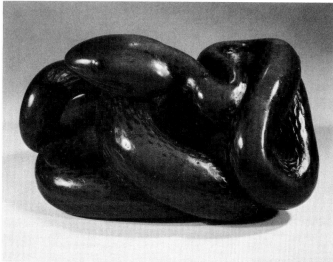

36. Snake

Snake deities were worshiped in early Shinto rites, but with the advent of Buddhism in Japan, the snake came to be associated with "female" passions of anger and jealousy. However, to dream of a snake was considered a good omen.

This reptile's satisfied expression and swollen midsection (more visible from the front) suggest a recent meal. The tiered undulations of its coiled body form a compact mass perfect for use as a netsuke. This carving has enjoyed considerable handling, and the smooth, worn surfaces of the outer coils and the top of the snake's head have a satinlike texture.

To the Japanese woman it is considered a compliment to imply that she is a "snake-year beauty." People born under this sign are extraordinarily intense and vain, but they also have great empathy for others.

Late eighteenth century. Wood, length 2¼ inches. Gift of Mrs. Russell Sage, 1910, 10.211.2284

37. Horse

Although Japanese horses are short-legged and stocky, they are difficult to depict standing in the compact netsuke form. This composition is similar to that of the tiger (no. 33)—the line of the neck and head curving along the body to form a smooth oval. The facial characteristics are well proportioned, with the eyes alert and the jawline strong. Tomotada worked mostly in ivory, a medium in which he seems most expressive, and his wood netsuke, such as this horse, lack the dynamic quality of his ivories.

Those born in the year of the horse are outwardly vibrant, showy, and talkative, yet inside they are weak and lack perseverance.

Eighteenth century. Wood, height 1⅞ inches. Signed: Tomotada. Gift of Mrs. Russell Sage, 1910, 10.211.1645

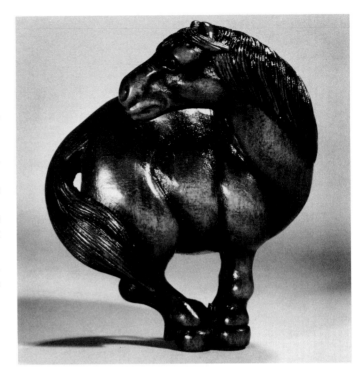

38. Goat

This zodiac sign can be translated as "sheep" or "goat." In Japan, where goat flesh is not eaten and the hair scarcely used, the animals rarely appear in any other art form. This artist, however, specialized in them, masterfully rendering the texture of their hair by meticulously carving the strands in layers. The horns lie gently on the goat's hunched back, resting on the hollow between the rib cage and the spine. This use of anatomy keeps the composition tight and comparatively smooth.

Deeply religious and timid, those born under this sign are considered creative thinkers who do well in the arts.

Nineteenth century. Wood, length 1¾ inches. Signed: Kokei. Gift of Mrs. Russell Sage, 1910, 10.211.2000

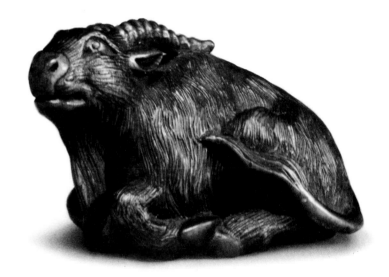

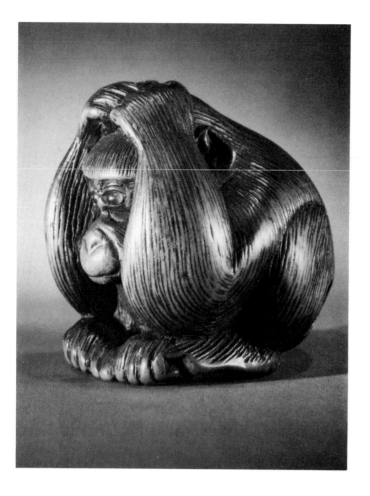

39. Monkey

Monkeys are native to Japan and play a large role in Japanese culture and religion. At first glance this figure appears to represent Kikazaru, the monkey who hears no evil, but a closer examination reveals uncovered ears in back of his hands. It seems probable the interpretation only intends to allude to this characterization; in reality the artist has deliberately utilized the arm posture to create a doleful creature whose purpose is simply to amuse.

This composition, though unsigned, is undoubtedly the work of Toyomasa. There are many examples of this design signed by him, and no other artist is known to have produced it. As in the Ryūjin (no. 73) by Toyomasa, the eyes of this figure have tortoiseshell inlays; the color of its stain is similar to that of other signed works; and each hair is precisely delineated, a sign of a careful artist and a characteristic of Toyomasa's technique and style.

Monkey people are quick, bright, and clever. Fast to anger, they as quickly become amicable.

Late eighteenth–early nineteenth century. Wood, height 1⅜ inches. The Edward C. Moore Collection, Bequest of Edward C. Moore, 1891, 91.1.1020

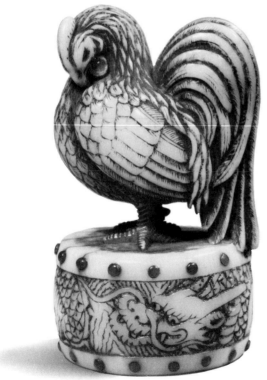

40. Cock

A cock on a drum is both a zodiac sign and a peace symbol. In China and Japan, the beating of a drum was a call to arms or a warning of danger. In Japanese folklore, when the unused drum became a perch for roosters, peace prevailed.

Here, the bird's head, tucked into the plump wing, is balanced by the high arch of the tail feathers, which blend harmoniously into a rounded form. The careful carving of the dragon on the sides of the drum is in opposition to the smooth drumhead, creating a textural contrast further dramatized by the studs of black coral on the rim.

People born in this year have a tendency to overextend themselves, and their fortunes are erratic.

Late eighteenth century. Ivory, height 1⅝ inches. The Edward C. Moore Collection, Bequest of Edward C. Moore, 1891, 91.1.1015

41. Puppies

The Chinese attitude toward dogs, associating them with bad luck and ill health, was gradually dispelled in Japan, where they became symbolic of loyalty and were much loved. Their reputation was considerably enhanced by the shogun Tokugawa Tsunayoshi. Born in 1646, in the year of the dog, Tsunayoshi was told by Buddhist priests that his lack of a son might be due in part to his killing of dogs in a former life, so he issued a proclamation protecting them.

This group of frolicsome puppies by Tomotada is an extraordinary composition that has been copied many times. From any angle the design is perfectly proportioned, and several natural openings allow it to be worn in different ways. Snapping jaws, tiny noses, and shell-like ears convey the youth and energy of these two little animals at play.

Those born in the year of the dog are loyal and honest. Somewhat eccentric and rather caustic, these people are known for their industriousness.

Eighteenth century. Ivory, length 1⅜ inches. Signed: Tomotada. The H. O. Havemeyer Collection, Bequest of Mrs. H. O. Havemeyer, 1929, 29.100.854

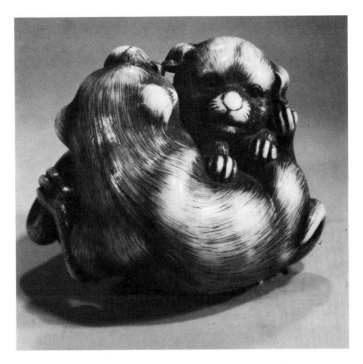

42. Boar

The boar, the twelfth zodiac symbol, is thought to possess reckless courage. It is found wild in western Japan, especially in the province of Iwami, where its tusks and teeth were carved by a group of netsuke artists.

This slumbering beast, nestled snugly in a bed of boughs and ferns, reveals both a gentle humor and a sense of brute force temporarily restrained. Although this design by Tomotada was frequently copied, no other artist has captured the power of the original.

People with this sign are forceful and determined to complete whatever they set out to do. They are faithful and honest in all their dealings.

Eighteenth century. Ivory, length 2¼ inches. Signed: Tomotada. Bequest of Stephen Whitney Phoenix, 1881, 81.1.91

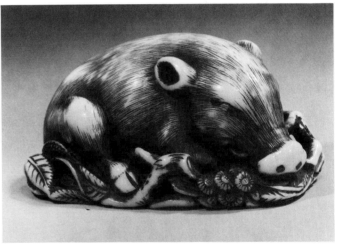

Manjū Forms

43. Kaminari-sama

The god of thunder, Kaminari-sama, is usually shown beating a drum in his aerial domain. Also known as Raiden (the Japanese word for both thunder and lightning), he is most often depicted as a demonlike creature with a scowling face and clawlike hands and feet, and in netsuke he resembles the creature known as an oni (no. 4).

Utilizing the *ryūsa* form, the innovative artist Toyomasa (nos. 39, 73, and 74) depicts Raiden's body suspended in air, surrounded by Chinese-derived "clouds." The ryūsa-style form, with its hollowed and pierced carving, provides a dark hollow recess that enhances the illusion of a figure suspended in air.

Late eighteenth–early nineteenth century. Wood, diameter 1⅞ inches. Signed: Toyomasa. Gift of Mrs. Russell Sage, 1910, 10.211.2066

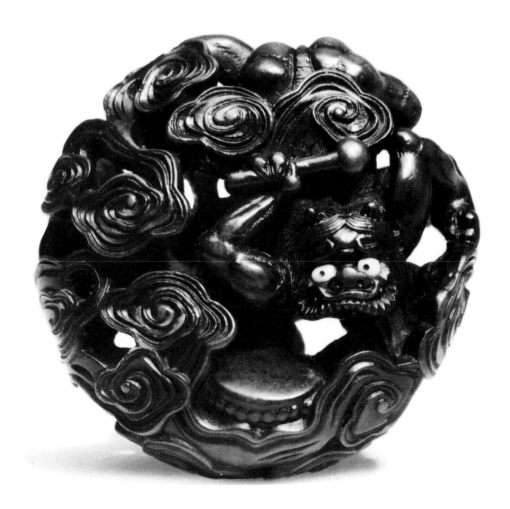

44. Still Life

Ryūsa, named for the carver who originated the style, is a form of manjū netsuke that is partially or wholly hollowed out and turned on a lathe. The broad, rounded edge allows the artist to continue his design uninterrupted from front to back.

This example, done with extraordinary skill, is probably the work of Ryūsa himself. Here the stippled surface gives the illusion of morning mist. The flowers and other vegetation, as well as the praying mantis, were fashioned by carving the surface of the ivory in a higher relief than the background, which was stained to provide textural contrast and added dimension. The hollow center adds a dark distance, and becomes part of the composition. On the reverse, also carved in relief, is a scarecrow in a field.

Eighteenth century. Ivory, diameter 2 inches. Gift of Mrs. Russell Sage, 1910, 10.211.1271

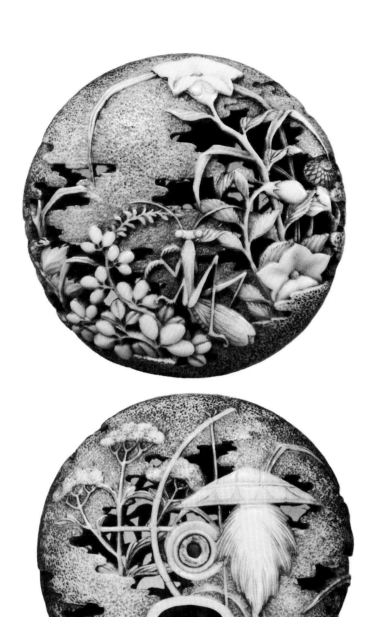

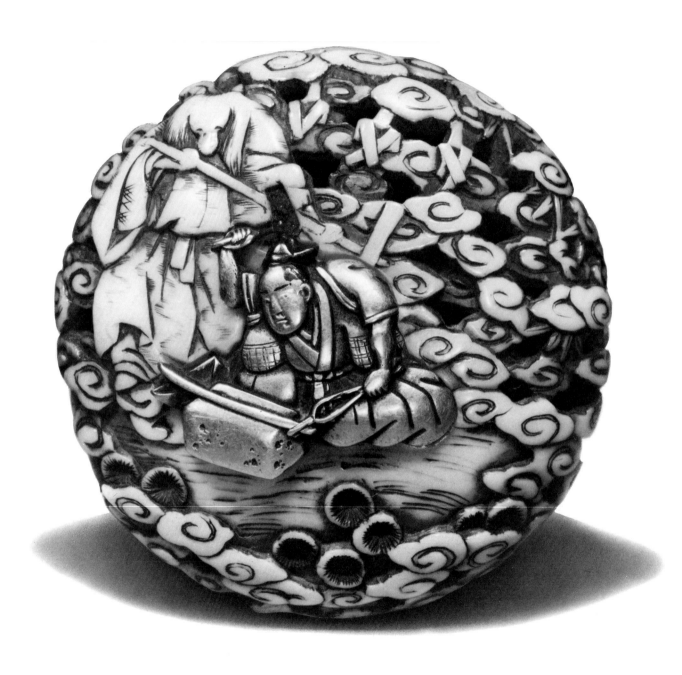

45. The Sword "Little Fox"

The sword is one of the three sacred symbols of imperial authority. From the earliest times in Japan, a spiritual presence, or *kami*, has been associated with the forging of a blade. This netsuke represents the creation of the sword "Little Fox," forged by the sword-smith Kokaji Munechika (938–1014) for the emperor Ichijō-tennō (reigned 986–1011). It is said that the fox god Inari manned the bellows during the making of the blade, and here his ghostly form hovers in the background.

In this ryūsa-style netsuke, Munechika is depicted in the metal cutout that fits into the surface of the ivory. The figure of the fox, cut in the ivory, is made all the more mysterious by the hollow, pierced ground, with its various intensities of dark and light.

Nineteenth century. Ivory and metal, diameter 1¾ inches. Gift of Mrs. Russell Sage, 1910, 10.211.1203

46. Spring and Fall

The seasons of the year are a dominant theme in all forms of Japanese art. The front of this manjū netsuke shows an autumnal scene—a goose flying over chrysanthemums and grasses. The bird is exquisitely rendered in an inlay style called *nonume* ("fishnet"), which uses gold and *shakudō*, an alloy that turns black when a pickling solution is applied to its surface. The hanging wisteria and the swallow in flight on the reverse side of this netsuke represent spring. The flowers are early examples of *shibayama*, the technique in which semiprecious materials such as tortoiseshell and mother-of-pearl are used as raised inlays. Named for an eighteenth-century netsuke carver, shibayama work first came to the attention of the West during the Meiji Restoration, and the resulting demand led to a decline in its quality. Most netsuke that have the shibayama signature in an inlay plaque were made during the mid-nineteenth century or later.

Late eighteenth century. Ivory and various inlays, height 1¾ inches. Gift of Mrs. Russell Sage, 1910, 10.211.1276

47. *Yoshitsune and Benkei*

Perhaps the most popular heroes to emerge from the early Kamakura period (1185–1333) were Minamoto Yoshitsune (1159–89) and his stalwart companion Benkei (d. 1189). According to legend, Benkei, an older monk with a greater taste for warfare than for meditation, met the young Ushiwakamaru (Yoshitsune's childhood name) at the foot of the Gojō Bridge in Kyoto. There the youth bested the experienced older fencer in a duel, whereupon Benkei swore everlasting fidelity to his new master. These two are the subject of countless netsuke.

The manjū netsuke seen here is called a kagamibuta (*kagami*, "mirror"; *buta*, "lid") and is composed of a metal disk set into a hollow bowl. The encounter at the Gojō Bridge is sharply executed on the gold disk, in the technique known as *katakiri-bori*. In this method incised chiseling produces lines of varying depth and width which simulate the brushstrokes in a painting. Masters of this form, like the artist Shūraku (1830–78), who carved this example, did not combine it with other techniques, as perfection of this skill was greatly admired. On rare occasions two artists who worked in the same or different mediums collaborated, probably at the special request of a patron.

The bottom of this netsuke was created by the artist Hakusai, who cut and pierced the hollowed stag-antler bowl in a leaf-and-flower design. The richness of the gold is in contrast to the simplicity of the antler. The bright metal represents wealth and display, while stag antler signifies simplicity and the beauty of nature.

Nineteenth century. Gold and stag antler, diameter 1⅛ inches. Metalwork signed: Shūraku and a kakihan (stylized signature); stag antler signed: Ha-kusai. The H. O. Havemeyer Collection, Bequest of Mrs. H. O. Havemeyer, 1929, 29.100.790

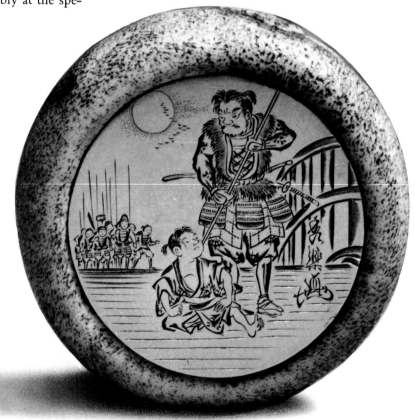

48. Emma Ō

This kagamibuta is the collaborative effort of two metal artists, each using a special technique and each signing the piece. Emma Ō, the ruler of the underworld, is shown warning against a life of dissipation.

The left side of the disk shows the reflection of a geisha in a mirror—a symbolic representation of the vanity and self-indulgence that leads to damnation. The work is simply incised, and the chiseled markings are stained black to stand out against the rest of the surface.

The figure of Emma Ō is the more dramatic portion of the lid. This section was first hammered lightly from the reverse, creating a repoussé design, and alloys and other forms of inlay were then added to the surface.

The various colors—red for the face, black for the moustache and beard, and gray for the body and background—are the result of a pickling process that forms a skin on the surface of each inlaid alloy. (The formula of the pickling bath was a closely guarded secret and still remains unknown in the West.) The gold finish of the inside of the figure's sleeve was applied by the mercury-oxidation method, in which gold and mercury are combined and then applied to the surface. When the treated area is heated, the mercury is oxidized, leaving the gold bonded to the surface.

Nineteenth century. Metal and ivory, diameter 1⅞ inches. Signed on left: Tenmin; inlay and repoussé work signed on reverse: Ryūminsai and a kakihan (stylized signature). Rogers Fund, 1913, 13.67.77

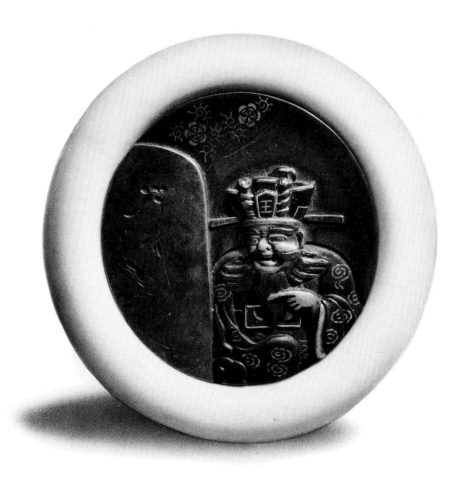

Mask Netsuke

GIGAKU, the first formal dance-drama using masks, was introduced into Japan from China in the early seventh century. About a hundred years later Bugaku, a collection of music and dances from some fourteen countries, was imported from the Tang court. Some of the masks used at that time have continued unchanged into the twentieth century.

Other masked dance forms evolved, but the ultimate in refinement and elegance was Nō, the dance-drama that emerged during the fourteenth century and that embodies all that is heroic and tragic in legend and historical literature. Kyōgen, a type of short farce that developed simultaneously with Nō, was noted for its rather ribald humor. It included elements found in the Gigaku, dances from the provinces, and other forms of burlesque which provided parody and humor. Nō and Kyōgen represent the duality of life, and they are always performed on the same program. For example, if there are three plays in a program, two might be Nō, with a Kyōgen performed between them for comic relief.

Until the advent of Nō, mask makers were usually Buddhist image carvers, but with the evolution of the Nō masks and the accompanying drama, more artistically oriented artisans were needed. The master mask carvers were specialized artists who understood the sophistication of Nō and who had the technical skill to communicate its meaning through sculpture. The first mask netsuke were probably carved as a hobby by a master mask carver.

The Deme school of mask carvers originated in 1500 and came under the control of the shogunate. Taking the name of one's birthplace as one's own name was quite common in the Edo period, so Deme, a town in Echizen Province (now part of Fukui Province), became the family name of the founder of the school, who was born there. Of the three official branches of this family which were under the direct patronage of the shogunate, the Deshi Deme was the first to make mask netsuke in the eighteenth century.

Carvers of mask netsuke were careful to duplicate the characteristics of the larger version in the smaller one. For instance, if the original had gold or bronze eyeballs, so did the corresponding netsuke. Most late Edo and early Meiji artisans, however, no longer attempted to make faithful facsimiles of the original masks, and they produced many mask netsuke that were only funny faces.

49. Garuda

In the Museum's collection are six masks of netsuke size which have no cord openings and are thus unwearable. They may have been made as a presentation set, or they may have served as models for netsuke carvers or been used as finger puppets. These pieces, which present masks of ancient dance-dramas in a small format, are of exceptional quality. The most interesting and complex example is that depicting the Garuda. This sacred bird, which ate poisonous snakes, came from ancient Indian mythology and entered the Buddhist pantheon as a guardian of Buddha. Gigaku masks of this creature dating from as early as the eighth century still exist, and the dance form associated with this mask was as lively and nimble as the face of the netsuke.

One test of a truly great mask was the placement of the eyes. The eye sockets had to be of equal size and shape with the pupils correctly positioned. This example is superb, and if it were larger, it could have been used by a performer, for its contours follow those of a human face.

Eighteenth century. Wood, height 1⅞ inches. Signed on inside plaque: Tori (literally, "bird"). Gift of Mrs. Russell Sage, 1910, 10.211.2383

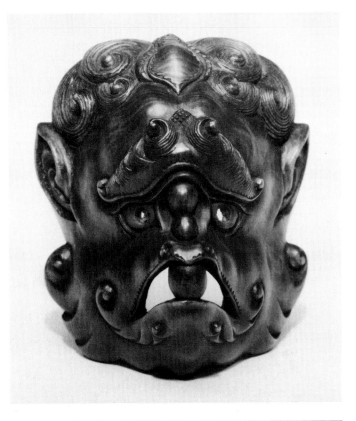

50. Sorrowful Old Woman

This mask netsuke represents a highly stylized version of Ouna, the old woman in the Ninomai, a dance from the Bugaku which is performed by an ugly old man and woman. The Ninomai, or "second dance," always follows the more formal version of the dance called Ama and is a comically grotesque parody of it. The man is always portrayed laughing, and the woman has a swollen face with a pained expression.

Nineteenth century. Wood, height 2¹/₁₆ inches. Gift of Mrs. Russell Sage, 1910, 10.211.2434

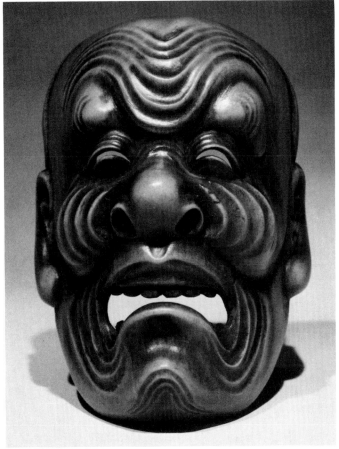

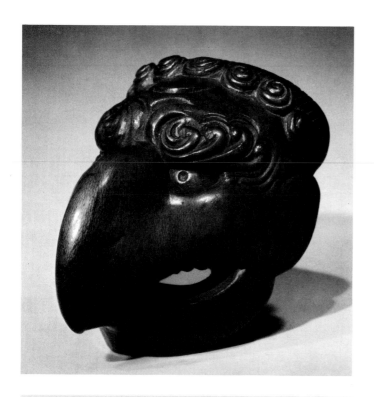

51. The Crow Tengu

The tengu was originally a Shinto deity of the mountains and was venerated in two forms—the long-nosed (*Konoha*) tengu, whose face was probably derived from that of Saruta-Hiko-no-Mikoto (no. 83) and who became known as the god of the roadways; and the crow (*Karasu*) tengu, which is shown here. Both creatures have birdlike bodies and humanlike limbs, with clawed feet and hands.

The crow type has a strong, curved beak. Legend states that these creatures helped those lost or in need while on journeys through deep forests, and it was also said that the king of the tengus taught Yoshitsune (no. 47) the art of fencing. Worship of the crow tengu lasted until the end of the Edo period.

This netsuke is unusual because of its well-defined upper teeth and sardonic grin. Nō masks of supernatural beings usually have brass inlays around the eyes to reflect the flickering lights during a performance, and this piece, like all fine mask netsuke, has this characteristic inlay.

Eighteenth century. Wood, height 1½ inches. Signed: Deme Uman, Ten-ka-ichi (this title, "first under heaven," was bestowed on the Deme during the early Edo period) and a kakihan (stylized signature). The H. O. Havemeyer Collection, Bequest of Mrs. H. O. Havemeyer, 1929, 29.100.733

52. Hannya

Hannya is a demon representing the spirit of a jealous woman. One of the most fearsome of all Nō masks, it is most often associated with the play *Dōjōji,* in which a young maiden falls in love with a handsome priest. Enraged by his resistance to her advances, she finally traps him under the bell of the Dōjō Temple. After turning herself into a snakelike dragon with the face of a Hannya, she encircles the bell and burns him to death with the heat of her anger.

Hannya are among the most common subjects of mask netsuke. This work is not a true copy of a Nō mask, as it lacks the reflecting metal or gilded eyes usually found in Nō masks of supernatural beings. However, the carving is superb: the strength of sculptural movement from the powerful forehead to the almost skull-like form of the cheek area and the jaw is the work of a skilled artist.

Nineteenth century. Wood, height 1⅞ inches. Gift of Mrs. Russell Sage, 1910, 10.211.2388

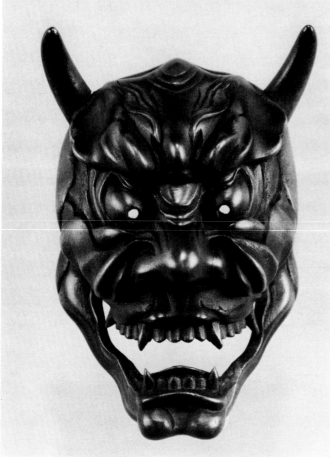

53. Mask of the Lion Dance

The Lion Dance, or *Shishi Mai,* the traditional Chinese New Year's dance, also has a long history in Japan. Similar masked dances can be traced to the original Gigaku and Bugaku dance-dramas, as well as to the Gyodō, the Buddhist procession containing a hidden object of religious significance. Lion masks are usually quite large, covering the entire head of the dancer; the lion's body is formed by two more dancers who are hidden under a long cloth attached to the mask.

There is also a hand-held-puppet version of this mask which is used in the dance-drama *Kagamijishi* (literally, "mirror lion"). This story tells of a dancer who, while performing, becomes possessed by the mask's spirit and is transformed into the lion itself. (*Kagamijishi* is a late nineteenth-century retelling of *Makura Jishi,* which was written in 1792.)

This netsuke is a replica of either the large or the smaller mask. Its ears swivel around as well as up and down, while the hinged jaw allows the mouth to open and close with the clacking sound of the larger versions. When open, the mouth reveals a curved tongue surrounded by rows of well-defined teeth. Even in its diminutive size, it has the same high spirits associated with the Shishi Mai, whose principal purpose is amusement.

Nineteenth century. Wood, height 1 7/16 inches. Signed: indecipherable kakihan (stylized signature). Gift of Mrs. Russell Sage, 1910, 10.211.2266

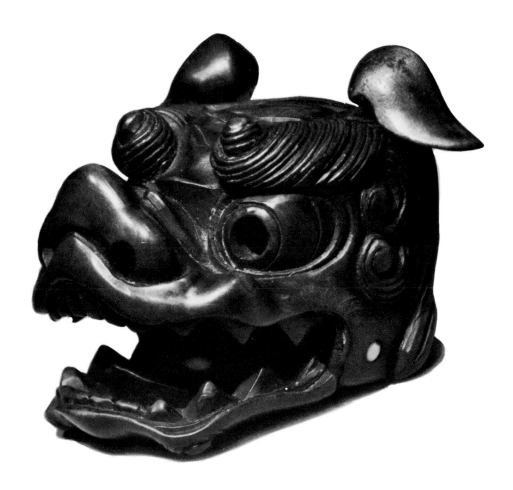

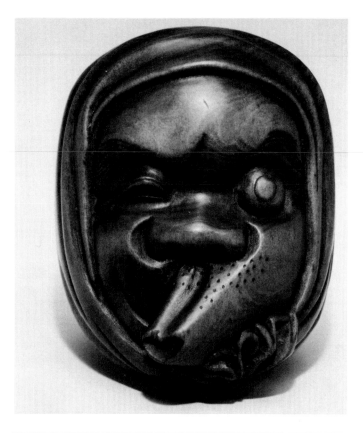

54. Hyottoko

Hyottoko is the generic term for a variety of masks based on a character known in Kyōgen as the "octopus man." These masks were derived from the Usobuki mask, originally called "the whistler" because of its puckered mouth. In the Hyottoko mask the lips were extended into a spout shape, and the protruding eyes of the original version were further exaggerated. The Usobuki mask originally represented the spirit of an animate or inanimate object as a rock or even a fly.

This netsuke resembles a drawing found in Hokusai's *Manga,* a nineteenth-century compendium of images suitable for copying by artists. It is similar to the mask for a character called Shio Fuki (literally, "blowing sea water"), which is found in the section on Nō masks. By the middle of the nineteenth century, the quality of mask netsuke had begun to decline, but in the late nineteenth and early twentieth centuries, artisans of the Sō school produced some superb, if less vigorous, replicas of earlier creations.

Nineteenth century. Wood, height 1^{15}/$_{16}$ inches. The Edward C. Moore Collection, Bequest of Edward C. Moore, 1891, 91.1.1059.

55. Otafuku with Wart

Oto, or Otafuku, is a modification of Okame (no. 83), a character found in Kyōgen after the fifteenth century. Otafuku is a term, with a vulgar connotation, usually applied jokingly to "big" women. Kyōgen masks tend to emphasize one particular aspect of facial characteristics, and in this case the exaggeration of the cheeks and mouth results in a grotesque parody of female beauty. The distortion of the fat cheeks and tiny pursed mouth is made more ridiculous by the wart above the left eye.

Nineteenth century. Ivory, height 1^{5}/$_{8}$ inches. Signed: Hidemasa. The Edward C. Moore Collection, Bequest of Edward C. Moore, 1891, 91.1.952

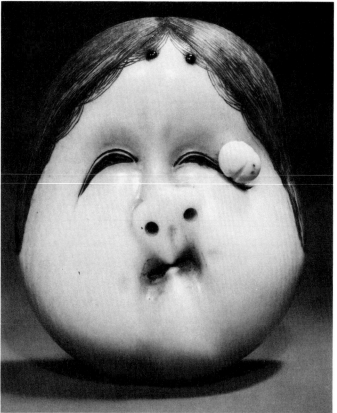

56. Cluster of Masks

Mask clusters became fashionable in the middle and late nineteenth century. This group of seven includes characters from Nō, Bugaku, and Kyōgen. The carving is sharp and clear, emphasizing the easily recognizable characteristics of each personality. For example, the seventh in the group is represented only by its eyebrows, which are visible at the top of the center mask. From this alone the Okina mask used in Nō can be identified. The signature plaque is part of the total composition and acts as the cord opening, completing a perfect netsuke form.

Nineteenth century. Wood, height 1½ inches. Signed: Shūgetsu saku (literally, "Shūgetsu made"). Bequest of Stephen Whitney Phoenix, 1881, 81.1.105

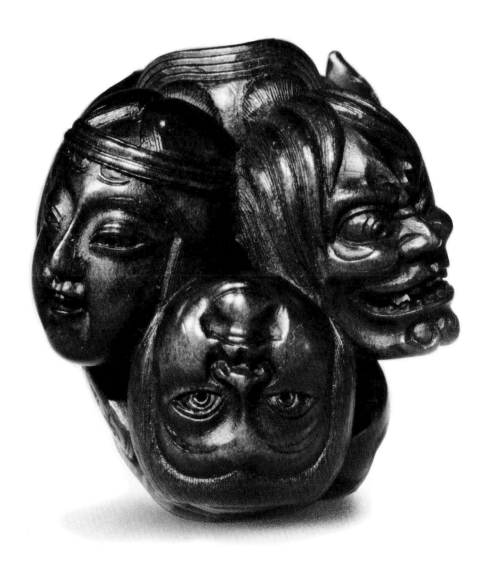

Animal Netsuke of the Nineteenth Century

57. *Tiger Grooming Itself*

Like Minkō, the artist Kokei was born in Mie Province, and it is known that he admired and often imitated Minkō's style. A comparison of the patterning on the body of this netsuke with that of no. 30 reveals similarities in markings and staining, but the design of this piece is original to this artist. Kokei is best known for his rather static renditions of goats (no. 38), and the composition of this tiger shows an elasticity of movement not usually found in his work. The type of composition seen here—in which the entire body is curled and appendages jut out from the central form—was rarely attempted in netsuke. Carving across the grain requires a masterful understanding of the medium as well as superb technique.

Nineteenth century. Wood, height 1¼ inches. Signed: Kokei. Gift of Mrs. Russell Sage, 1910, 10.211.1982

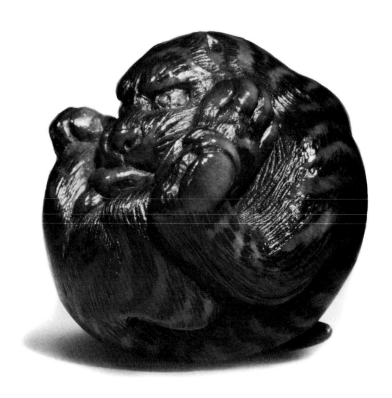

58. Tanuki in Lotus Leaf

Sukenaga (worked c. 1818–29), the creator of this sculpture, came from Takayama in Gifu Province, an area known for its beautiful yew trees. He invented the technique known as *ittobori,* that is, single knife-stroke carving, which results in a figure marked by broad angular planes. He was also known for his exquisitely concise sculptures, of which this is an excellent example.

This netsuke of a *tanuki* in lotus dress is a more pointed statement than the eighteenth-century version by Garaku (no. 26). Where Garaku saw humor in his allegory, Sukenaga, whose talent lay in sharpness of concept and precise detailing, set forth his views on the sobriety of the priestly class with more severity. With most of the figure enveloped in a huge leaf, the sharp, ferretlike face with its small, gleaming yellow eyes, which peer out from under the lotus bonnet, creates a sinister impression.

Nineteenth century. Wood, height 2 inches. Signed on stem at back: Sukenaga. Gift of Mrs. Russell Sage, 1910, 10.211.2098

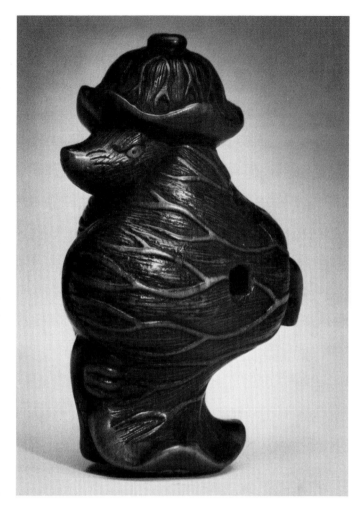

59. Bat and Offspring

Because the Chinese characters for "good luck" and "bat" are pronounced the same, this animal became symbolically linked with good fortune. Bats, however, seldom appear in Japanese art, and most netsuke depicting them were created by the artist Hōraku. Little is known about this artist except that he concentrated his creative energy on portraying bats in a style which shows little variety.

This gentle, furry creature, clutching her two offspring in her wing, has the strong maternal quality with which Hōraku usually endowed his bats. She gazes solemnly at the world through shiny black-inlay eyes; with a rounded muzzle and small, shell-like ears, she resembles a koala rather than the fearsome night-flying creature common in Western iconography.

Nineteenth century. Wood, length 1¾ inches. Signed: Hōraku. The Edward C. Moore Collection, Bequest of Edward C. Moore, 1891, 91.1.1051

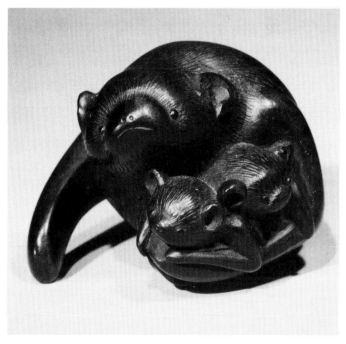

60. Octopus and Monkey

This unlikely combination probably alludes to an episode in the legend of Ryūjin in which the Dragon King's doctor, an octopus, prescribes the liver of a live monkey as the cure for an ailment. A jellyfish is sent to find a monkey but fails in his mission, and the story ends there. However, the pair shown here is often depicted in netsuke, probably indicating that the octopus finally undertook the task itself.

The excellence of this netsuke lies in the skillful use of dissimilar shapes and forms, and in the artist's ability to communicate some of the terror and physical pressures of the fight. (Struggle for survival is a common theme in Rantei's netsuke.) The expressions are exaggerated, and the force with which the monkey pushes his adversary is seen in the indentation in the octopus's head.

Unlike earlier Kyoto artists who concentrated on the larger, individual zodiac animals, Rantei, an exceptional artist for his generation, was a stylish innovator. He and his followers usually worked with combinations of figures in a smaller format. Despite the smaller size, however, they were able to give their netsuke greater expression through more realistic detailing.

Nineteenth century. Ivory, length 1½ inches. Signed: Rantei. The Edward C. Moore Collection, Bequest of Edward C. Moore, 1891, 91.1.962

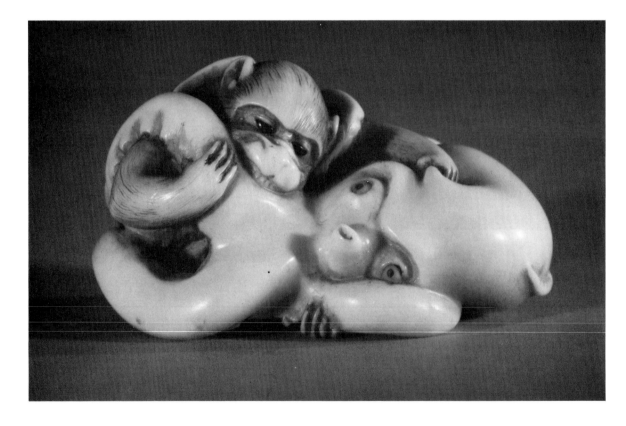

61. Monkey

The monkey is much loved in Japan and is the subject of many paintings and netsuke. The small, light-furred, and short-tailed variety (*Macaca fuscata*) is found throughout the islands and in the north is sometimes called the "snow monkey." The year of the monkey is considered unlucky for marriages, as the word for monkey (*saru*) has the same pronunciation as the verb "to leave," or "to divorce."

Masatami delighted in carving this animal in various textures. The face is molded in smooth planes; the inlay of the eyes is black coral. The body is carved with every hair carefully delineated, and its forelegs are beautifully tapered, terminating in minutely articulated fingers and fingernails. The smoother, lighter chestnut, accented by a bug, offers a contrast to the detail and darker color of the monkey.

Nineteenth century. Ivory, length 2¼ inches. Signed: Masatami. Gift of Mrs. Russell Sage, 1910, 10.211.1065

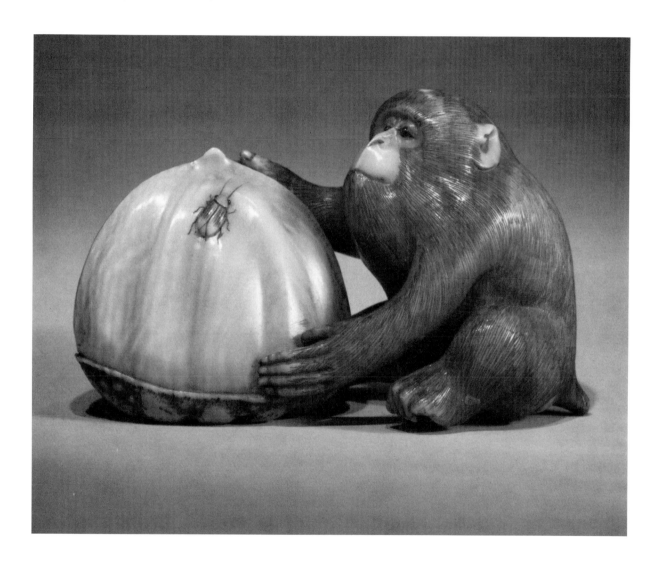

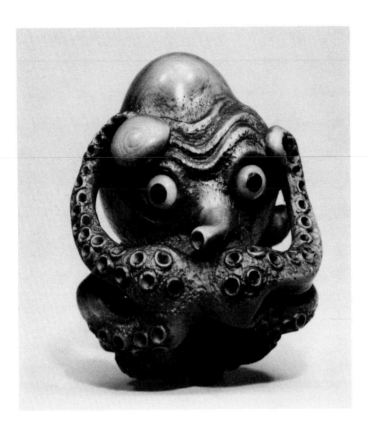

62. Octopus

The octopus has provided the Japanese with food for their imagination as well as for their table. It is sometimes identified as a messenger of Ryūjin, the King of the Sea.

The humorous treatment of the octopus is enhanced by the careful insertions of ivory and black coral, creating bulging eyes which stare in an almost quizzical manner. The realism of the twisting tentacles is heightened by the accurately rendered suckers lining their sides. The oversized head is minutely stippled, simulating skin.

The octopus sometimes represents Yakushi, the Buddha of Healing, and the wearer of this netsuke might have used it as a constant prayer for good health, its serious intent masked by a humorous exterior.

Nineteenth century. Wood, height 1¾ inches. Gift of Mrs. Russell Sage, 1910, 10.211.1991

63. Hawk

In Japan, the hawk is a symbol of masculinity, and hunting with hawks was a popular sport among the samurai. This bird's great power is expressed in its spread wings and cocked head glaring down at its prey, a dog. Its mouth and tongue are deeply undercut to emphasize the sharp curve of the beak. Black inlaid eyes contrast with the light ivory of the body, and a stain accents the play of light and dark throughout the composition. The placement of the hawk's claw in the dog's eye heightens the brutality of the struggle.

Nineteenth century. Ivory, height 2 inches. Signed: Hidechika. The H. O. Havemeyer Collection, Bequest of Mrs. H. O. Havemeyer, 1929, 29.100.796

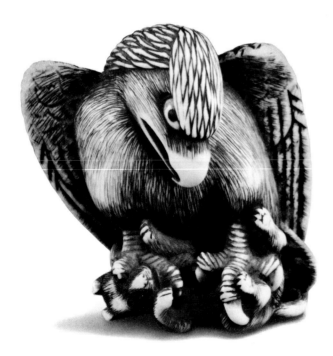

64. Owl and Two Owlets

Owl netsuke are comparatively rare because these birds were thought to be harbingers of death. It was also said that they ate their young. The artist of this sculpture softens the typical association by adding tiny offspring to the composition, as well as interpreting the night bird with appealing features.

Okakoto, who worked in the first half of the nineteenth century, was the student of the eighteenth-century master Okatomo of Kyoto (no. 18). Little is known of his personal history. However, it seems probable that his early works are most similar to those of his teacher and that as he became independent, his compositions reflected the newer tastes of the nineteenth century.

Stag antler, the material used here, has larger pores than ivory, and the artist has successfully used the peculiar physical properties of his medium by allowing this cellular formation to function as holes in the log. Clever carving across the grain gives a smooth, hard surface, which has been enhanced by deep staining and polishing.

The only owl netsuke known from the pre-Meiji period use this same design—the female owl is shown with two (or one) owlets which peer out of the recessed cavities that represent their nests.

Nineteenth century. Stag antler, length 1½ inches. Signed: Okakoto. Gift of Mrs. Russell Sage, 1910, 10.211.995

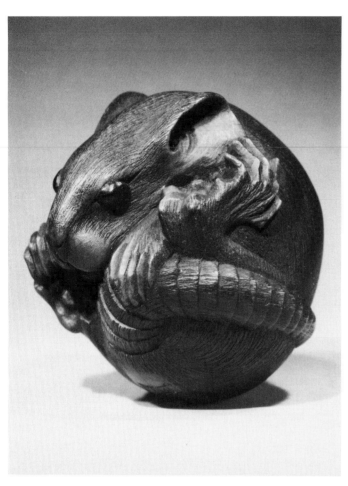

65. Coiled Rat

A sketchbook of Masanao I (1815–90) of Ise Province has survived, and therefore this netsuke is one of the few for which the artist's original design can be documented. Like most great sculptors, Masanao was a gifted draftsman, and his drawings are superb.

Rather than mar the smooth, rounded lines of his compositions with separate cord openings, Masanao always used the natural opening between the body and the paw for the stringing of the cord. This tight composition was often copied, and even today in Mie, *okimono* (larger sculptures of frogs and other animals) are carved in the style Masanao created more than a century ago.

There is a line of artists who sign themselves Masanao which can be traced directly to this particular master. Differentiation can only be made by the manner in which the last character of the name is signed, as similarity of style was much admired in Japan. The mark of a good pupil was his expertise at copying his teacher's work. If the work met the high standards of the teacher, he might then sign his own name. This method of teaching was common among nineteenth-century netsuke carvers.

In making the judgment as to the true creator of this particular netsuke, many elements must be considered, among them the quality

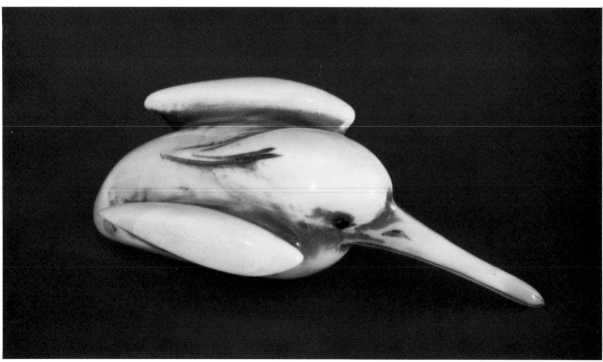

of the carving (in this case the exactness of the individual strands of hair), the color of the stain, the placement of the cord opening, the patination that has been acquired through age, and the manner in which the last character of the name is signed. Considering the superb qualities of this sculpture, one has no doubt that this piece is by Masanao I.

Nineteenth century. Wood, height 1½ inches. Signed: Masanao. Gift of Mrs. Russell Sage, 1910, 10.211.2004

66. Kingfisher

Birds other than sparrows and falcons, which have symbolic associations, are seldom found in netsuke. This artist has portrayed a kingfisher in a very simple and smooth form. The wings curve and blend into the body, creating a slick surface broken only by the cord openings on the underside. Befitting this small, quick bird, the tiny black inset eyes add a quality of alertness.

Nineteenth century. Ivory, height 2⅜ inches. Signed: Yasuchika. The Howard Mansfield Collection, Rogers Fund, 1936, 36.100.183

67. Kappa

The *kappa,* a fantastic aquatic creature, appeared in netsuke during the nineteenth century. Traditionally, it has a tortoise body, frog legs, and a monkeylike head with a saucer-shaped hollow in the top. This indentation contains fluid that makes the kappa ferocious and uncompromising. However, being Japanese, it is very polite; when bowed to, it will bow in reply, losing the fluid and, consequently, its strength. It walks upright, and its face is usually that of a pouting child rather than a terrifying monster. Kappas are reputedly responsible for drownings, but they can be propitiated by throwing cucumbers, their favorite food, into the water.

In this superbly elegant and sophisticated netsuke, no surface has been left uncarved. The head is gracefully modeled, and small ears peep through the sharply defined, striated hair. The body's texture appears to imitate tortoiseshell, and the froglike limbs end in webbed feet. The carving is sharp and precise, which is typical of mid–nineteenth-century work, and one of the characteristics of the style of this artist.

Mid–nineteenth century. Wood, height 1⅞ inches. Signed: Shoko. Gift of Mrs. Russell Sage, 1910, 10.211.1858

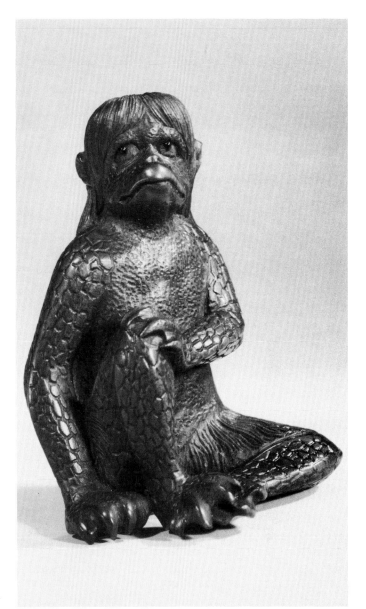

68. Rabbit

This white rabbit is a masterpiece of understated simplicity and elegant design. Although very compact, it is subtle in its sophisticated modeling. The legs are tucked out of sight, but the long ears are articulated with loving attention. Despite the abstraction of shape, the proportions remain lifelike, and the rabbit appears alert, as do most animals depicted in nineteenth-century netsuke. The sharp eyes are inset with black coral, and the whiskers and nostrils defined in black to stand out more clearly against the white ivory.

Ōhara Mitsuhiro (1810–75) was born in Onamichi, a small town near Hiroshima. He studied poetry and the tea ceremony and belonged to the Zen sect of Buddhism. Going to Osaka when he was seventeen, he became an apprentice to a maker of plectra for the koto. He practiced carving on discarded scraps of ivory and soon became renowned for his skill. Because of poor health he returned home in 1857 and died there in 1875. One of the outstanding netsuke artists of the mid-nineteenth century, Ōhara Mitsuhiro was a versatile carver who used many styles and techniques, and his pieces ranged from the complicated and detailed to the extraordinarily simple.

Mid-nineteenth century. Ivory, length 1½ inches. Signed: Mitsuhiro and Ōhara (in a seal). The Edward C. Moore Collection, Bequest of Edward C. Moore, 1891, 91.1.975

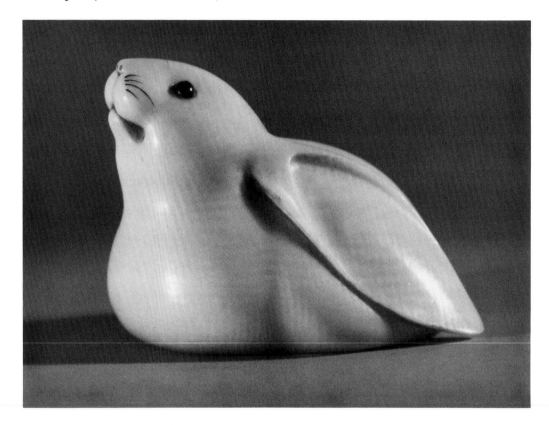

69. Boar

When netsuke were introduced to Europe in the Meiji period, variations on traditional subjects evolved that were thought more appealing to Western taste. For example, Kō-hōsai of Osaka, who created this boar, felt that a sleeping, ferocious animal (no. 42) would not be appealing to either the export market or the Western-influenced home market, so he developed a new approach to the subject.

This boar's head is large compared to its body size, and the facial expression is amusingly exaggerated. To embellish this netsuke, the artist included a decorated back covering with an elegant dragon pattern. Hanging beads are simulated by colorful incrustations of semiprecious stones in the technique known as shibayama. The signature plaque on the underside bridges the space between the legs and provides the cord opening.

Late nineteenth century. Ivory, length 2¼ inches. Signed: Kōhōsai and a kakihan (stylized signature). Gift of Mrs. Russell Sage, 1910, 10.211.899

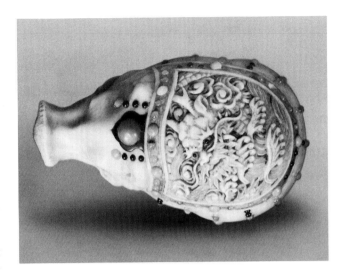

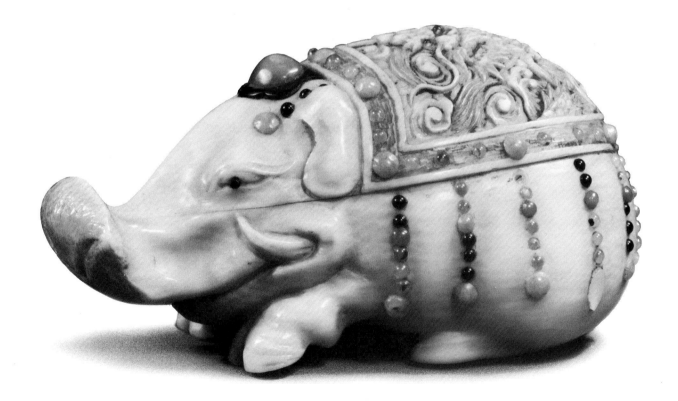

70. Mushroom, Frog, and Flower

The mushroom was a popular subject for netsuke because its two surfaces, each with a different texture, allowed the artist to display his technical skill. In this piece the upper surface with its simple curves and smooth undulations contrasts with the sharply delineated ribbed underside. The chrysanthemums carved on the undersurface of the fungus, accompanied by a frog, suggest autumn and the approaching cool weather.

Nineteenth century. Ivory, height 1⅝ inches. Signed: Ren. The Edward C. Moore Collection, Bequest of Edward C. Moore, 1891, 91.1.984

71. Symbols of Good Fortune

At the Japanese New Year, it is considered good fortune to dream of a falcon, an eggplant, or Mount Fuji. Falcons are identified with persistence and success, eggplants signify fruitfulness, and to dream of Mount Fuji is an omen of the greatest luck. The netsuke illustrated on the opposite page incorporates all three symbols and may have been intended as a New Year's gift.

The sagemono was not hung from the opening formed by the stem of the eggplant, but from cord openings carved in the back of the netsuke.

Early nineteenth century. Ivory, length 2⅜ inches. Signed: Sadayoshi. The H. O. Havemeyer Collection, Bequest of Mrs. H. O. Havemeyer, 1929, 29.100.751

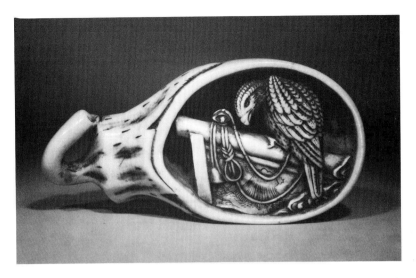

72. Kuzunoha and Infant

In Japanese legends fact and fantasy are often intermingled. It is said that while walking near an Inari shrine, Abe no Yasuna, father of the famed astronomer Abe no Seimei (d. 1005), protected a fox that was being pursued by hunters. A short time later he met and married a beautiful girl named Kuzunoha. One legend tells that she died in childbirth, another that she left her husband to return to the forest and assume her true vixen form. In any event, before her departure she is said to have written a farewell poem to her husband.

This netsuke depicts the fox-mother Kuzunoha holding Abe no Seimei in her arms. The brush in her mouth, made of yellow-and-red-stained ivory, alludes to her farewell poem and adds textural contrast to the composition.

Abe no Seimei was the court astronomer to the emperor Fujiwara Michinaga (966–1027). Because of his skill in astronomy, he became associated with the occult and took on a semilegendary character.

Nineteenth century. Wood and ivory, height 1⅝ inches. Signed: Masakazu. Gift of Mrs. Russell Sage, 1910, 10.211.2046

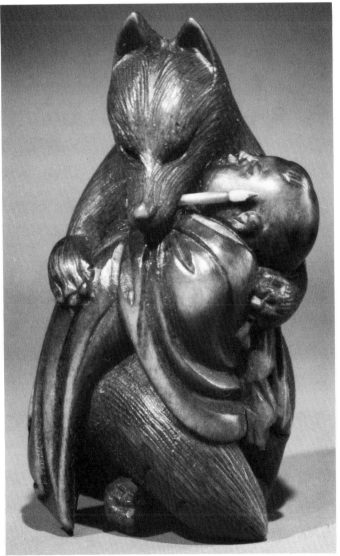

Figural Netsuke of the Nineteenth and Twentieth Centuries

73. *Ryūjin, the Dragon King*

Toyomasa (Naito) (1773–1856) of Tamba Province was an artist who achieved an extraordinary synthesis between the spontaneity of the eighteenth century and the realism of the nineteenth century. His works represent what could be termed a "transitional style."

He was known to worship the Dainichi-Nyōrai ("Great Sun Buddha"), indicating that he belonged to one of the esoteric sects of Buddhism and was familiar with a rich pantheon of supernatural beings. He created many versions of several basic designs, the Gama Sennin (no. 74) probably being his most popular.

With rare exceptions Toyomasa used *tsuge,* a light-colored boxwood to which a stain, made from *yasha,* a kind of nut, was usually applied. After the piece had taken on the dark brown shade he favored, some areas were lightened by polishing. Large, bulbous eyes of inlaid tortoiseshell, whose yellow color contrasted with the dark-stained wood, are characteristic of his animal and figural sculptures. The open-mouthed expressions on the faces of both men and beasts are also a hallmark of Toyomasa's style.

This figure shows an extraordinary curvilinear flow. In this piece and in his Gama Sennin, the artist has chosen a spot slightly above the central image as the focal point of his composition. Here all movement flows from the "pearl" which Ryūjin holds high above his head. Both man and dragon seem to flow from it. This feeling is heightened by the hair, beard, and garments which swirl from the stationary figure. The dragon, executed in sharp detail, encircles the man's body, but the relationship between them is not as symbiotic as in the earlier Ryūjin (no. 12) in the style of Shūzan.

Early nineteenth century. Wood, height 2⅞ inches. Signed: Toyomasa, roku-ju yon sei ("Toyomasa, sixty-four years old"). Bequest of Stephen Whitney Phoenix, 1881, 81.1.120

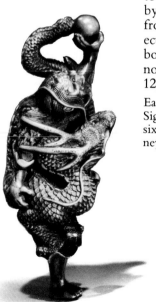

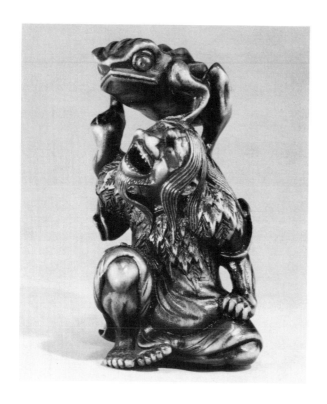

74. *Gama Sennin*

The legendary Gama (toad or frog) Sennin is the subject of many folktales. Most commonly, he is identified with the sage Kōsensei, who was skilled in the use of magical herbs. Kōsensei lived in the mountains with a large toad, and occasionally, while bathing, he took on the form of his familiar. Countless variations of the story exist, usually presenting a loving relationship between the sage and his companion.

Most of Toyomasa's netsuke use natural apertures in the composition for threading the cord. This technique allows the entire design to be viewed without the distraction of carved holes. (Separate cord openings are more commonly found in nineteenth-century netsuke than in those created in the eighteenth century.)

It is said that Toyomasa was frequently imitated, and his son Toyoyasu often signed his father's name. However, it was not customary for a son to sign his father's name while the latter was alive. Judging this example on stylistic grounds as well as on its signature and quality of work, one has no doubt this piece was carved by the father.

Early nineteenth century. Wood, height 2⅛ inches. Signed: Toyomasa. Gift of Mrs. Russell Sage, 1910, 10.211.1894

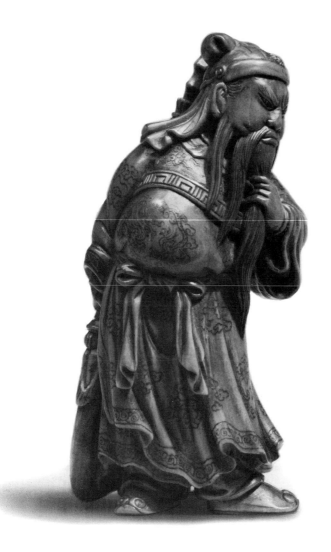

75. *Kuan-yü*

This nineteenth-century Kuan-yü with scowling expression and sweeping gesture is more realistic than the quiet, imposing, eighteenth-century depiction (no. 1). It shows the sharper delineation of form characteristic of nineteenth-century netsuke, but its shorter and stockier shape fails to convey the sense of power inherent in the earlier figure. The relative lack of refinement of the later netsuke is evident specifically in the beard carved in

separate sections, resulting in a loss of fullness and depth, in the less elegantly formed front hand, and in the less complicated contour of the sleeve. Here the general merely grasps rather than caresses his beard. The earlier example represents an elegant Chinese gentleman in meditative stance, while this later interpretation is more earthy and robust, reflecting Japanese taste.

Nineteenth century. Wood, height 3⅛ inches. Gift of Mrs. Russell Sage, 1910, 10.211.2316

76. *Gama Sennin*

In this piece the well-defined, muscular physique and menacing expression of the holy man are unusual—sennin are usually presented as benign, clothed figures. Here is a strong-willed, determined, earthy creature; his familiar, however, is unimposing and seems almost extraneous.

The artist who signed this netsuke is unknown, and bears no relationship to the Shū-zan (no. 12) whose name is pronounced the same but written differently.

Late eighteenth–early nineteenth century. Ivory, height 5¼ inches. Signed: Shūzan. Gift of Mrs. Russell Sage, 1910, 10.211.1499

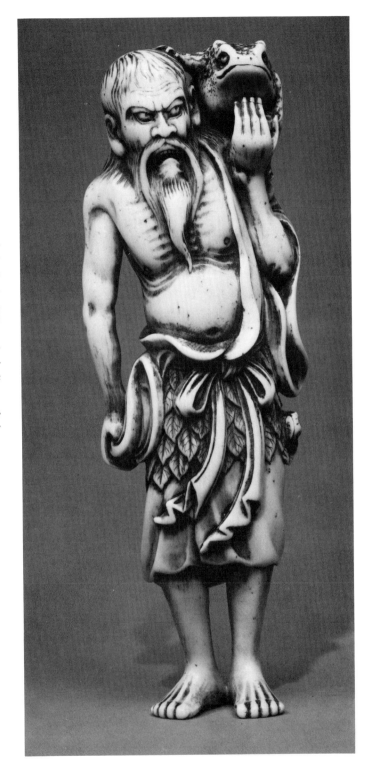

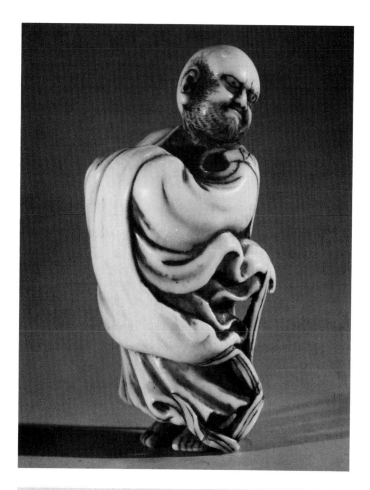

77. *Daruma Crossing the Yangtze*

Founder of the Ch'an (Zen in Japanese) sect of Buddhism in China, the Indian monk Bōdhidharma, known in Japan as Daruma, traveled as a missionary from India to southern China about A.D. 520, but finding no welcome there, crossed the Yangtze River to settle in the north. This netsuke depicts him crossing the river on a reed. Bōdhidharma, his robe folded over his hands, displays a stern countenance set in deep concentration. The rippling of the long robes suggests motion and also emphasizes the upright posture of the body, balanced precariously on the single reed and braced against the wind.

Nineteenth century. Ivory, height 1⅞ inches. Gift of Mrs. Russell Sage, 1910, 10.211.731

78. *Daruma Enraged*

One legend concerning Daruma tells of his meditating for nine years facing the wall of a cave. During this period, he fell asleep and upon awakening, screamed in consternation because he had been unable to remain awake. Here, his rage is fondly reproduced. Although netsuke usually depict him beardless, this rendition gives him eyebrows, a moustache, and a short beard composed of small spiral curls, a form usually associated with the hair depicted on early sculptures of the Buddha. The eyes are sorrowful rather than angry and are marvelously expressive in their downward droop. The flow of the garment is simple, but the careful execution of feet and hands with sharply defined nails is an indication of the increasing emphasis on realism. Gold lacquer is applied for color.

Late eighteenth–early nineteenth century. Wood, height 3⅛ inches. Signed: Sensai tō (literally, "Sensai's knife"). Gift of Mrs. Russell Sage, 1910, 10.211.2346

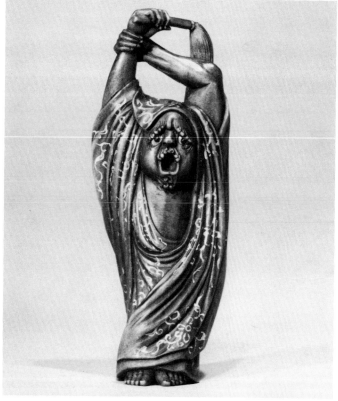

79. Skeleton and Skull

This superbly articulated rendition of a skeleton astride a skull is a humorous statement of the transitory nature of life. The bony hips of the skeleton are modestly covered with a loincloth, a reminder of its humanity and also an iconographic detail found on demonic figures of the eighth century. The careful definition of the skeletal structure demonstrates the knowledge of anatomy on the part of this artist, Rantei, who often created subjects dealing with death or the struggle for survival (no. 60).

In this netsuke the head and arm were made as a separate unit and then inserted at the top of the spine and into the shoulder. This construction provided movement and also allowed for the contraction and expansion caused by changes in humidity.

Nineteenth century. Ivory, height 1¾ inches. Signed: Rantei. Bequest of Stephen Whitney Phoenix, 1881, 81.1.72

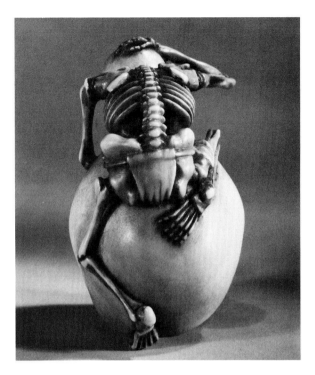

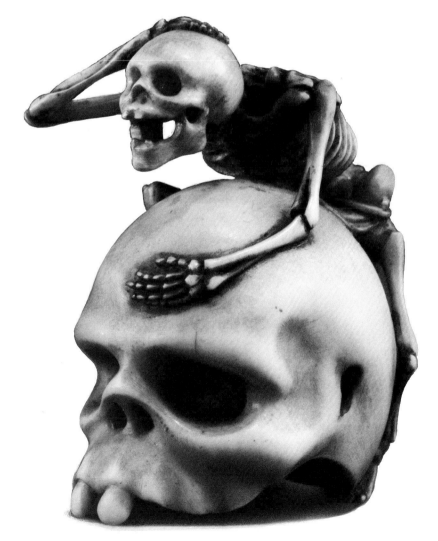

80. Kintarō

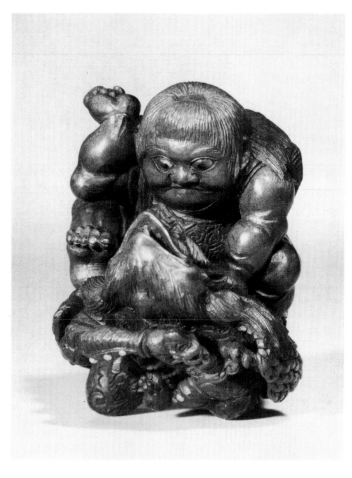

Kintarō, who was brought up in the mountains, had superhuman strength. As a small child, he could uproot trees and wrestle bears, and was constantly fighting other beasts and goblins. Most often he is depicted overcoming the tengu (no. 51), which is part bird and part other animal or man, that lived deep in the mountain forests.

Here, boy and beast are in the final stages of a struggle. Both are exceptionally well delineated. The boy's hair and features are sharply described, and tortoiseshell eyes with black inlaid pupils add a realistic touch. His body is rounded with exaggerated but softly contoured muscles that are indicative of his strength. The tengu, on the other hand, is on its stomach with wings spread in the posture of weakness, and bends its head backward in a feeble attempt to peck at Kintarō. Every feather of the tengu is carved individually, and small ivory inlays highlight its arms and legs, creating a contrast to the wood. The emphasis on realistic detail and intricate carving, characteristic of early nineteenth-century netsuke, adds complexity to this piece but does not detract from the vigor of the composition.

Early nineteenth century. Wood, height 1⅜ inches. Signed: Hachigaku. The Sylmaris Collection, Gift of George Coe Graves, 1931, 31.49.12

81. Ryūjin's Daughter

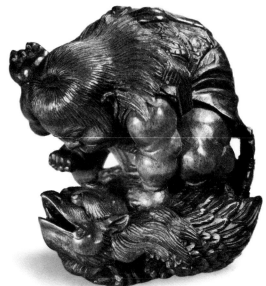

According to legend, Ryūjin, the Dragon King of the Sea, had two daughters. One was the famed Otohime, whose name may be traced back to mythology of the eighth century; the other, who is not named, is said to wear a fish as a headdress. Any artistic interpretation of this second daughter and her familiar is unusual, and this netsuke appears to be unique.

The woman's face, with its sharply defined features, bears a marked resemblance to the fish perched on her head, producing an amusingly grotesque effect. The Chinese-

style robe is softly contoured and falls gently against the trousered legs. Her arms bend gracefully, and her elegant, long-fingered hands hold a heaping basket of sea urchins, as if making an offering. The back of the sculpture is intricately carved, and the rear panel of her garment is cut in the shape of a scaled fish. The cord openings are integrated into the patterning of the design.

Nothing is known about the artist who created this imaginative sculpture.

Nineteenth century. Wood, height 3¼ inches. Signed: Yokeisai and seal. Gift of Mrs. Russell Sage, 1910, 10.211.2325

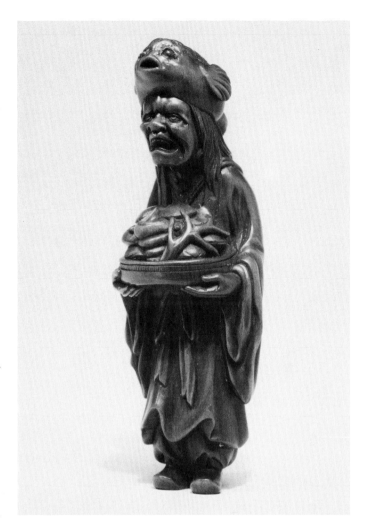

82. Hotei

According to legend, a group of seven gods, whose origins derived from Brahminism, Taoism, Buddhism, and Shinto, appeared in a dream to the shogun Tokugawa Iemitsu (1603–51). In explaining the dream, a courtier pronounced them the Seven Gods of Good Luck. Hotei, the most popular of the group, is commonly portrayed as a fat, jolly figure with an ample stomach, usually carrying a bag and holding a fan. This fan, which represents authority, is one of the *takaramono,* a collection of twenty-one objects usually found in the bag which symbolize prosperity. Here, Hotei himself sits in his bag.

This example by the well-known artist Ōhara Mitsuhiro combines elegant simplicity and exquisite detail. The smiling fat face and the pudgy arm protruding from the bag create an appearance of joviality. The well-carved folds and stitching on the bag lend authenticity to its fabric, and the fine details of Hotei's features and fan provide a textural contrast to its smooth, worn material. This counterpoint of textures is often found in Mitsuhiro's work.

Nineteenth century. Ivory, height 1⅛ inches. Signed: Mitsuhiro and Ōhara (in a seal). The H. O. Havemeyer Collection, Bequest of Mrs. H. O. Havemeyer, 1929, 29.100.841

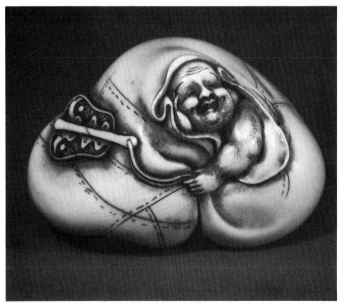

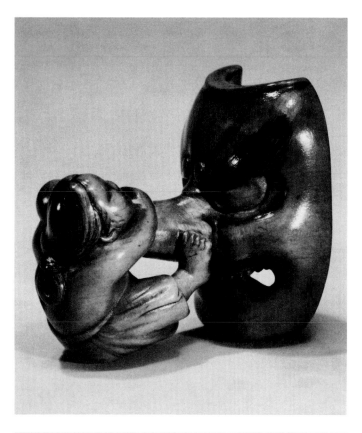

83. Okame and Mask

The small figure clinging to the top of the long nose of this mask is the popularized form of Uzume-no-Mikoto, who, according to a well-known Japanese legend, danced to entice the sun goddess Amaterasu out of a cave where she had hidden, thus depriving the world of light. Okame, as the deity is also known, created such raucous merriment that Amaterasu emerged, and light was restored. Certain Shinto songs and dances are said to trace back to those of Okame. The legends concerning the pantheon of Shinto deities are based on chronicles written, for the most part, in the eighth century, and as time progressed, they became accepted by the Japanese as fact. Here Okame is shown grasping the nose of the mask, which represents Saruta-Hiko-no-Mikoto, the Shinto god who blocked the crossways to heaven. The sun goddess asked Okame to confront him and clear the way.

The humorously erotic relationship illustrated here is often seen in netsuke of the Edo period. This Okame is a playful young girl; her rounded body and chubby arms, hands, and feet give her a childlike innocence which contrasts with the scowling mask. By using opposites, the artist Masanao has created a successful satire.

Nineteenth century. Wood, height 1½ inches. Signed: Masanao. Bequest of Kate Read Blacque in memory of her husband Valentine Alexander Blacque, 1938, 38.50.296

84. Sleeping Shōjō

Shōjō are mythical red-haired creatures who live near the sea and have a great liking for intoxicating beverages. They especially enjoy sake and are usually shown with drinking containers such as jars, dippers, or cups. In the Nō play Shōjō, these creatures have red hair and animal features. In netsuke, however, they are usually depicted with long dark hair and childlike features and with their bodies curled in the sleeping position shown here.

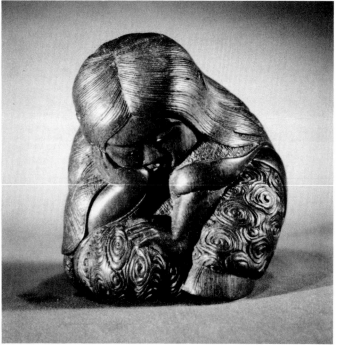

In this example, the tiny ears peek through the hair which falls down the back, hugging the contours of the body. Small, gently molded features and curled fingers complete the childlike modeling of the body. The creature's garment is covered with a "diaper" pattern, a Chinese-derived design. The appealing characterization belies the fact that the shōjō is "sleeping it off."

Two artists from the same period used the name signed on this piece, and it is impossible to determine which one created it.

Nineteenth century. Wood, height 1³/₁₆ inches. Signed: Masakazu. The H. O. Havemeyer Collection, Bequest of Mrs. H. O. Havemeyer, 1929, 29.100.826

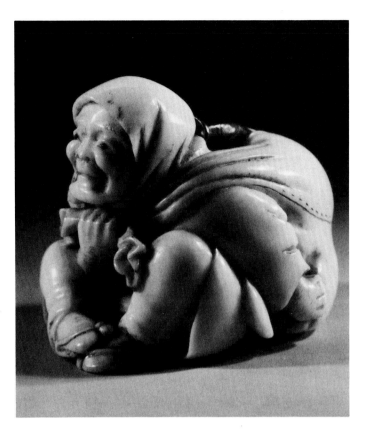

85. Old Man

An old man weary of carrying his bag of troubles rests for a moment. His burden takes the form of oni, or demons, who are trying to free themselves. One, stained green, has torn a hole in the bag and glares out between his fingers with a single eye (right). Another is about to grasp the old man by his coat collar.

The man wears a netsuke and tobacco pouch made of wood with tiny brass highlights (repeating the metal ornament on the larger versions). The arm of the grasping oni is of wood, and its wrist is encircled by an inlaid metal bracelet. Inlays of various materials were applied only sparingly to eighteenth-century netsuke, but in the nineteenth century, artists increasingly used distinctive combinations as a statement of individual style.

This subject was originated during the latter part of the eighteenth century by Ryūkei, who carved it in dark-stained boxwood. This ivory copy, with its metal inlays, called for techniques not associated with ivory carving and is possibly the product of two artists.

Nineteenth century. Ivory, wood, and metal, height 1¼ inches. Signed: Seikanshi. Gift of Mrs. Russell Sage, 1910, 10.211.907

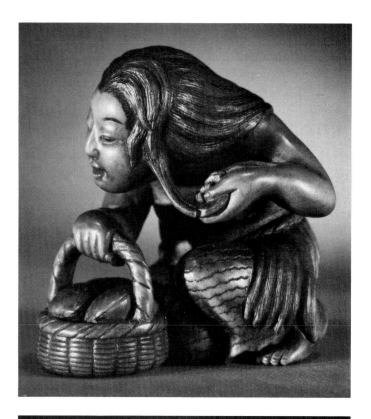

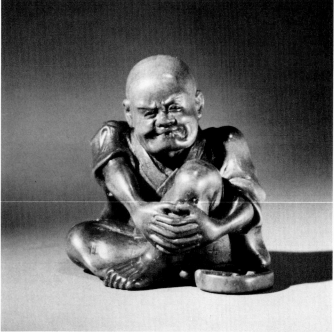

86. Fisherwoman

It is still customary in Japan for women rather than men to dive for crustaceans, perhaps because women are better able to withstand cold. This is a sensitive rendition of a clam gatherer in traditional dress. Her long hair is tied in a knot, and her undergarment is covered by a bamboo overskirt and belted with a fiber rope.

The kneeling figure is perfectly proportioned, and the angled body creates shadow and light which add to its lifelike quality. Soft facial molding and rounded contours contribute to the feeling of femininity as the graceful creature pushes back a lock of her hair. Exquisite fingers and toes complete the masterful execution.

This netsuke bears the early signature of the great mid-nineteenth-century master whose full name was Masatsugu Kaigyokusai (1813–92). Born in Osaka, he was a man of independent wealth; it is also known that he was self-taught, studied calligraphy, and sketched all angles of his intended project before starting it. While this careful process led to extraordinary technical prowess, it sometimes resulted in a lack of spontaneity and liveliness. As a very young man, he used the signature Masatsugu, and then, from the age of twenty to thirty, Kaigyokudō. He then signed himself Kaigyoku until he was about fifty, after which he signed Kaigyokusai or Kaigyokusai Masatsugu.

Nineteenth century. Wood, height 1⅝ inches. Signed: Kaigyokudō. Gift of Mrs. Russell Sage, 1910, 10.211.1664

87. Monk Applying Moxa

Moxa, a cauterizing agent made from leaves of the wormwood tree, is still used in the treatment of many ailments. This netsuke is an expressive portrait of a monk clutching his knee and grimacing as the moxa, here a black shiny inlay applied to the surface of the wood, does its work. Comparison of the piece with that by the artist-innovator Hōjitsu (no. 88) allows the viewer to observe a stylistic evolution that extended over a period of seventy-five years.

Hōjitsu (d. 1872) introduced the concept of genre figural netsuke. His associate and friend Ikkōsai (1804–76) had a son named Ikkōsai Kōjitsu (1833–93), who became a pupil of Hōjitsu. It was this pupil who be-

came the teacher of Josō Miyazaki, who in turn became the master of what became known as the Sō school.

Hōjitsu's interpretation has a quiet elegance and grace not readily apparent in his descendant's work. Josō, on the other hand, concentrated on facial and body expressions, with the countertensions made visible through skillful knowledge of anatomy. The more direct expression is seen in the clenched jaws and tensed muscle structure; the tendons of the foot stand out and the toes curl. Yet, as this figure is of a monk and not a laborer, the artist has endowed it with long, graceful fingers, and there is softness evident in the gently molded body. Josō is an extraordinary artist, and this example is a masterpiece.

Nineteenth century. Wood, height 1 inch. Signed: Josō tō (literally, "Josō's knife"). Gift of Mrs. Russell Sage, 1910, 10.211.1828

88. Man Applying Salve

By the late Edo and early Meiji periods, competition among netsuke carvers had exhausted conventional themes, and artists searched for fresh subjects. During the 1850s the artist Yamada Hōjitsu (d. 1872), a vassal of the shogun, was patronized by the daimyo of the Tsugaru District of Mutsu Province. His creation of netsuke for such powerful clients earned him the reputation of being the finest carver in Tokyo. He began to specialize in genre figures, depicting in his sculptures the daily activities of townspeople. His work, thought to have been influenced by the genre painter Hanabusa Itchō (1651–1724), is refined, with few frills.

This man applies salve to a painful area on his neck. Although his face is contorted with suffering, it is still well-defined enough to be a portrait. The countermovement within the body is emphasized by the tilt of the shoulders and the folds of the garment as it gathers in the man's lap. His slender wrist and forearm draped in a rippling sleeve are elements of studied grace.

Nineteenth century. Wood, height 1¼ inches. Signed: Hōjitsu. Gift of Mrs. Russell Sage, 1910, 10.211.1823

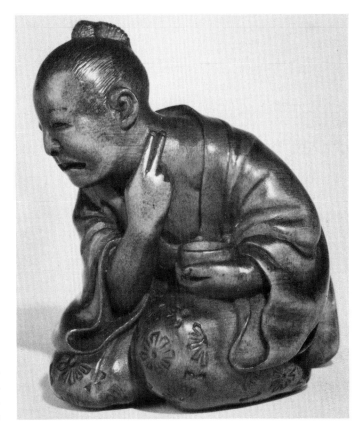

89, 90. Seated Shōki and Kneeling Oni

Little is known about the artist Tokoku, the carver of these netsuke. Apparently self-taught, he started his own school in Tokyo in 1862. He created a style that used multicolored inlays in combination with different materials. For example, the appendages of a figure might be of ivory and the clothing of wood, with additional highlights, such as carved lacquer, inserted for color and textural contrast. An expert technician, he was strongly influenced by Buddhist philosophy and Confucian morality. He was a master of anatomy with an eye for precise realism.

These are two matched examples of his work. Together they afford a unique opportunity for study and for a comparison that demonstrates how each material has its own rewards. The example in pure ivory on the left is rare, as Tokoku seldom worked solely in that medium. It has been lightly stained to provide greater contrast, thus heightening dimensionality and tonal quality. This prudent use of color subdues the freshness of the ivory, mellowing its appearance. The beard is shorter in the ivory example, and the features are quite clear, partially because of the medium used.

The wood netsuke displays the artist's preference for the sensitivity and warmth of this material. The face, though less distinct because of the exceptionally dark stain Tokoku frequently used, is actually livelier than that of the ivory piece. Here he used the white of ivory as inlays for the eyes to contrast vividly with the darkened wood. The body of Shōki is more rounded, and the drape of the kimono sleeve is softer and more fluid. The two oni are nearly identical except for the greater fullness of the wood image.

From the back both Shōki are seen seated on stools, the underbases of which are identical in both pieces. The ivory netsuke has one opening shaped like the head of a Jō-i, a sculptural form symbolic of Buddha's authority. This shape appears in the same place on the wood netsuke, but in a simpler form as part of a repeat pattern. The cord opening of the wood netsuke (on the bottom) is lined with stained ivory, which protects the wood from rapid wear.

89. Nineteenth century. Wood, height 1¼ inches. Signed: Tokoku (in seal writing). Gift of Mrs. Russell Sage, 1910, 10.211.1815
90. Nineteenth century. Ivory, height 1¼ inches. Signed: Tokoku (in seal writing). Gift of Mrs. Russell Sage, 1910, 10.211.716

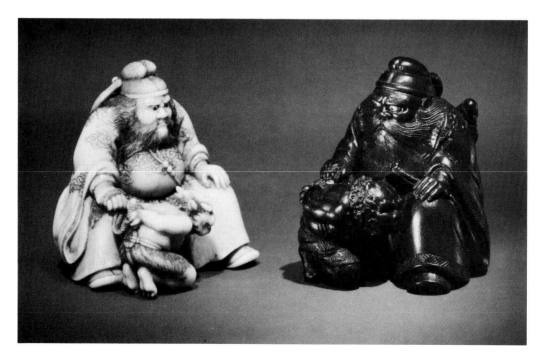

91. Man Cutting Pumpkin

While Hōjitsu provided the impetus for the proliferation of genre subjects, Josō Miyazaki (1855–1910) further shifted the emphasis from the activities of the upper and middle classes to those of workmen and farmers. The man at right, kneeling in Japanese fashion, is cutting a pumpkin. His headband, originally a sweatband, is traditional among workers in Japan even today. This netsuke displays great vitality. The expression on the man's face is intense, and his long tapering fingers energetically grasp the vegetable as he cuts it.

At a time when the export market demanded flashy inlays and overly decorated, intricate pieces, Josō concentrated on the smaller home market. Typically, his netsuke were of simple subjects, exquisitely executed. Determination and tension are expressed in the faces, finely muscled bodies, and strong hands of his workers. Occasionally he carved other figures—a crying child or a blind man—but they are all treated with sympathy rather than ridicule.

Late nineteenth century. Wood, height 1¼ inches. Signed: Josō yafu tō (literally, "Josō the rural man's knife"). Gift of Mrs. Russell Sage, 1910, 10.211.1827

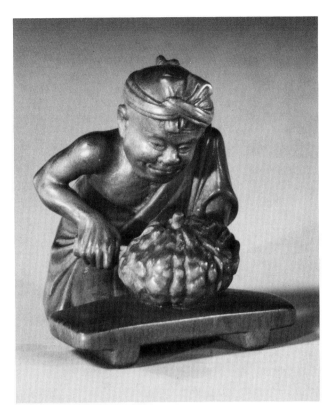

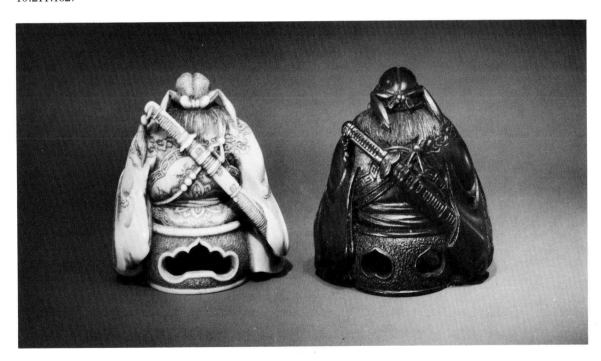

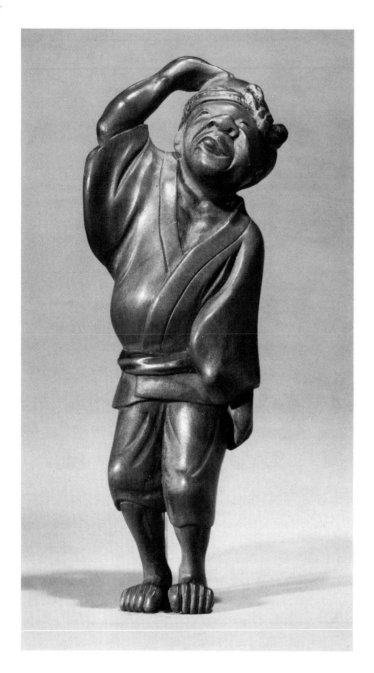

92. Drunken Laborer

Kokeisai Sanshō (1871–1926), the creator of this netsuke, was known for his genre figures. He tended to exaggerate facial characteristics as a means of stylistic expression; here, for example, the twisted features suggest drunkenness.

The well-proportioned body, clothed in a casually draped, simple garment, is pure Sanshō. The hair is stained black to emphasize the headband, part of the workingman's costume. The bare, tightly curled toes grasp the ground to maintain balance. The netsuke, however humorous, may have had a serious intent: it might have served as a reminder to its owner of how foolish one looks when drunk.

Late nineteenth century. Wood, height 3¼ inches.
Signed: Sanshō and a kakihan (stylized signature).
Gift of Mrs. Russell Sage, 1910, 10.211.2353

93. Elephant and Blind Men

The image of the elephant has stimulated the Japanese imagination for centuries. Early Buddhist paintings and sculpture depict the deity Fugen Bosatsu seated on the beast, and mythological animals sometimes derive characteristics from it (no. 22). In the early part of the eighteenth century a pair of elephants was sent to Japan as a gift to the imperial family, and netsuke of that animal could easily have been based on drawings from life.

This is an interpretation of the allegory concerning truth and how man interprets it.

The blind men are investigating an elephant in an attempt to describe it. Their findings, of course, are based on which part they feel.

The tininess of the figures against the beast's expansive body is meant to be as amusing as the humor reflected in the animal's face. This is a sensitive rendition by the founder and master of the renowned Sō school of netsuke carvers and the creator of nos. 87 and 91.

Late nineteenth century. Ivory, height 1⅝ inches. Signed: Kuku Josō tō (literally, "Kuku Josō's knife"). Gift of Mrs. Russell Sage, 1910, 10.211.900

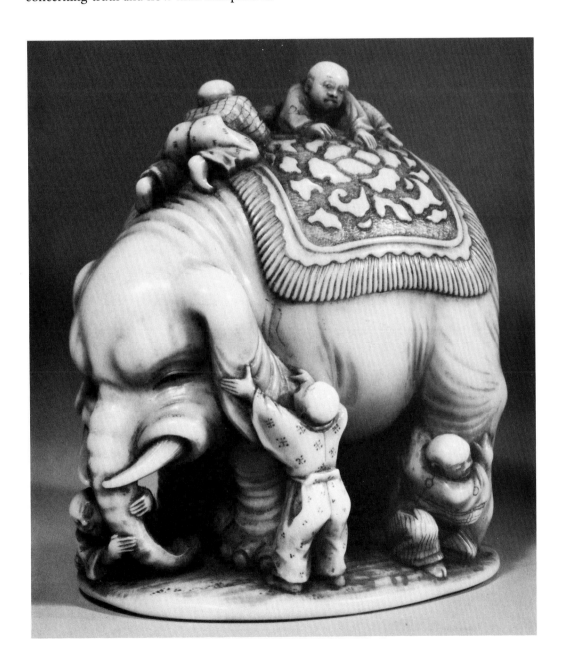

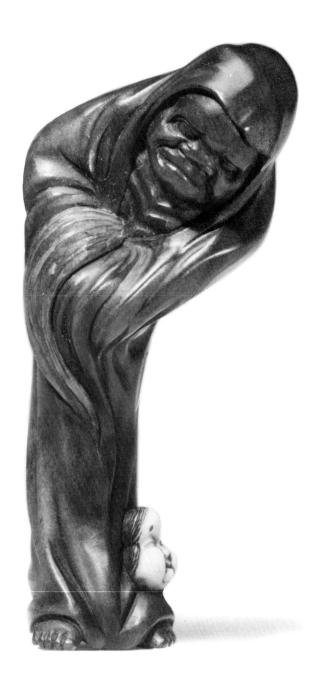

94. Daruma Tempted by Okame

This netsuke alludes to the constant temptations that beset the celibate Daruma. Its satirical spirit is unmistakable. Many Buddhist priests, supposedly celibate, often visited geisha houses or had women brought to the temple, and netsuke artists often pointed out this hypocrisy. In most art forms of the Edo and later periods, Daruma is usually fondly ridiculed as being more human than legendary.

The exaggerated scowl of Daruma's face, as well as the overextended curve of the figure as it bends first away from and then toward Okame, humorously expresses his dilemma. The artist Sanshō (see also nos. 92 and 97) is known for his satiric representations of people and their follies. The composition is amusing and relates its message. The successful balancing of the figure is an artistic triumph.

Late nineteenth century. Wood with ivory insert, height 3 inches. Signed: Sanshō and a kakihan (stylized signature). Gift of Mrs. Russell Sage, 1910, 10.211.2315

95. Ono no Komachi

The few dignified or graceful representations of women in netsuke are of heroines of the Heian period (794–1185), a time when women enjoyed considerable success in the arts. Ono no Komachi (834–900) was a renowned court beauty as well as an accomplished poet. At the height of her glory, she was said to be extravagant and proud, setting impossible tasks for her lovers, until one of them died in the pursuit of her favors. Out of remorse, or perhaps as punishment by the gods for her extreme vanity, she became destitute in her old age. In netsuke, she is often portrayed as a toothless hag dressed in rags.

This is a rare sympathetic interpretation of the poet in her last years. The carving of her face is particularly sensitive, and the hint of a dimple in her cheek is a poignant reminder of her former beauty. Her expression is reminiscent of a poem (*waka*) which she wrote and which appears in the *Kokenwak-ashū* ("The Collection of Ancient and Modern Waka"):

> Now that I am old
> And fallen into years
> of wintry rains
> The very foliage of your love
> Is but a rack of withered leaves.

Takehara Chikkō of Osaka is known for his figural netsuke of Japanese legendary subjects.

Late nineteenth–early twentieth century. Wood, height 3½ inches. Signed: Chikkō saku (literally, "Chikkō made"). Gift of Mrs. Russell Sage, 1910, 10.211.2336

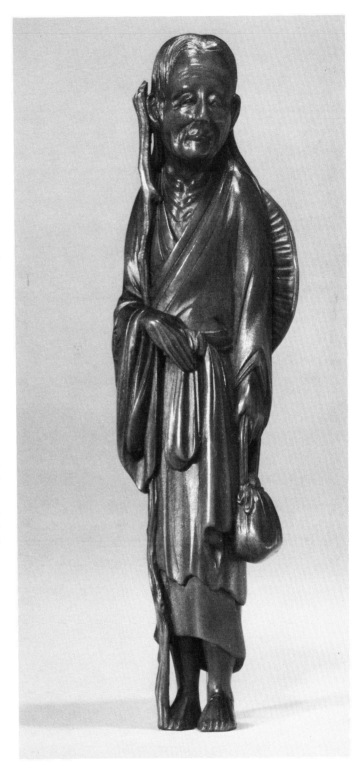

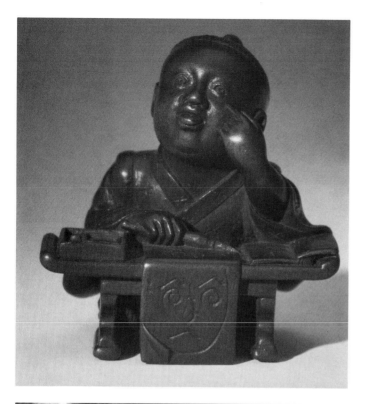

96. Child at Writing Table

This little boy at his writing table, probably in a temple classroom, has made an error in copying his assignment. Probably because he has just been scolded, he has put his brush down and leans forward on his desk, making the gesture known in Japanese as *bekkanko* behind his teacher's back. Bekkanko is a derisive gesture in which a child sticks out his tongue while pulling the corner of his eye down.

The front of the boy's exercise book shows that he has been doodling instead of paying attention. The characters on the paper are in reverse—Japanese is written with brush, ink, and water (note implements on desk), and the student's writing has soaked through to the back. The letters, in the syllabic form of Japanese that children learn first, have no particular meaning but have been used to draw a funny face.

This extraordinary carving, by the previously unrecorded artist Sōgaku, typifies the finest-quality netsuke created for the Japanese home market in the late Meiji and Taishō periods. The carver was probably also a student of Josō (nos. 87, 91 and 93), as the subject matter, costuming, and style of carving are typical of that school.

Early twentieth century. Wood, height 1⅜ inches. Signed: Sōgaku tō (literally, "Sōgaku's knife"). Gift of Mrs. Russell Sage, 1910, 10.211.1816

97. Spirit of Victory

The headdress worn by this unusual figure is composed of three mother-of-pearl disks inlaid in wood frames, and its shape is based on that of the *matoi,* an implement used in victory celebrations during the Meiji period. On the disks are scratched the characters of *Dai Nihon Senshō Iwai* ("Celebration for Japanese Victory"). This netsuke was carved by Sanshō (1871–1936), and it is likely that it commemorates the Japanese victory in the Russo-Japanese War of 1904–5. The figure's face reflects the agony of battle, and the whisk and necklace of leaves, symbolic of Buddhism, allude to that religion's condemnation of war.

This is a striking piece, rendered with both delicacy and force, and its subject indicates that it was not intended for export. Although there is little published material concerning the artist Sanshō, it is evident from his netsuke that this form still attracted talented and imaginative artists who were willing to work against the radically changed social order, dress, and philosophy. Sanshō's subjects are refreshing reminders of a culture whose concepts were quite alien to the Western world only fifty years ago.

Early twentieth century. Wood, height 4⅛ inches. Signed: Sanshō and a kakihan (stylized signature). Gift of Mrs. Russell Sage, 1910, 10.211.2319

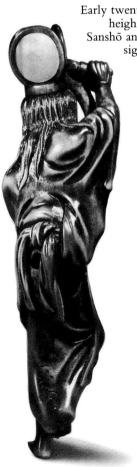

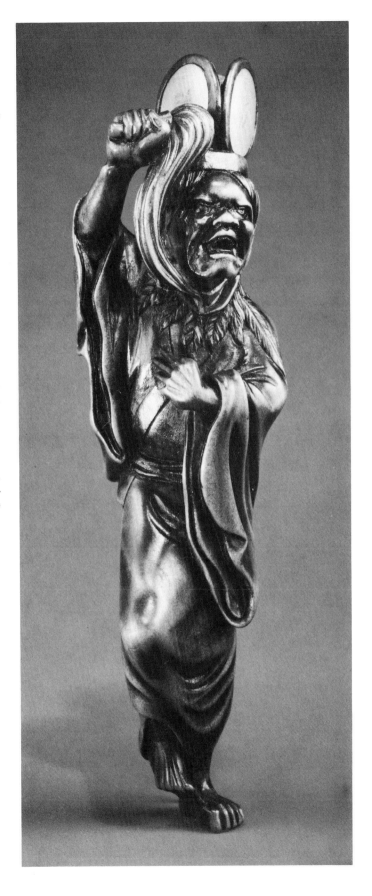

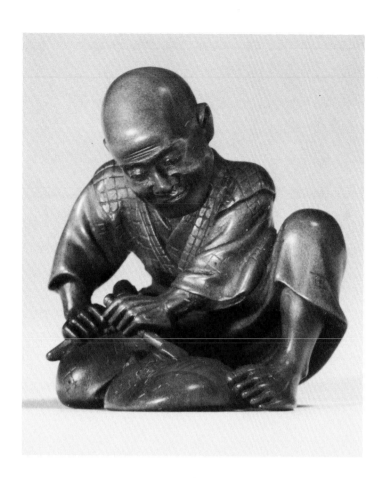

98. Mask Carver

A mask carver as subject offered the artist an opportunity to display his virtuosity in the accuracy of his carving and the vivacity of the action depicted in the sculpture. Genre subjects (no. 88) became popular in the Meiji period, and their popularity for the home market continued through the Taishō period (1912–26). It is important to note that pieces for export—genre carvings in both the smaller netsuke and the larger okimono—were almost always made of ivory. Only the home market appreciated the warm, natural qualities of wood.

This netsuke of a mask carver was made by an unrecorded artisan, probably a pupil of Josō (nos. 87, 91, and 93). This example has the same qualities evident in his work as well as that of others from that school.

The countertension within the body of the mask carver is masterfully conveyed by the tilt of the head, the angularity of the shoulders, and the position of the left foot, curved inward to brace the body against the stress caused by the descent of the mallet and chisel. The carver's countenance mimics the twisted expression of the Hyottoko mask (no. 54) he is carving.

Like most carvings for the home market, this piece is marked by great care in all aspects of its design. A natural aperture has been left under the body to serve as the cord opening as well as the signature plaque.

Early twentieth century. Wood, height 1¼ inches. Signed: Sōkyu tō (literally, "Sōkyu's knife"). Gift of Mrs. Russell Sage, 1910, 10.211.1826

Forgery—A Study in Connoisseurship

NETSUKE FORGERIES seldom appeared until the late Edo period, when the increasing value of the originals made production of forgeries financially worthwhile.

In 1974 The Metropolitan Museum of Art accepted a netsuke (no. 99) as an example of a deliberate forgery of high quality. Soon afterward the collector Charles Greenfield was struck by its similarity to an example in his own collection, and he subsequently donated the netsuke (no. 100) to the Museum so that the two examples could be used together for comparison.

Both of these pieces illustrate the more common version of a Dutchman's costume, including tight leggings, soft low shoes, and a long tunic with a right-hand closing, buttons on the cuff, and a frilled undercuff. The Dutchman's hat was usually shown as soft and rounded, its wide brim turning up and away from the face and its softly rounded crown hugging the head. Occasionally Chinese-style hats appear on figures of Dutchmen in the eighteenth century, but Korean-style hats like that seen on no. 99 were not used on Dutchmen's figures until the late nineteenth century. Thus the hat on this figure provides evidence of stylistic deviation, suggesting that this example may be a problem piece or possibly a forgery. The abbreviated, upturned circular brim suggests a Chinese style, but this is incongruously combined with the short, stiff sizing of the crown which is reminiscent of the forbidden early seventeenth-century portrayal of Portuguese hats. Hats similar to that shown here appear on nineteenth-century inrō depicting Korean acrobats.

The Greenfield netsuke has a wear mark on its protruding forehead, but there is little sign of wear on any of the surfaces of the forgery. Moreover, the cord openings of the Greenfield netsuke have sloping sides, indicating use, while those on the forgery have sharp edges. Although it could be held that the forgery was a treasured piece which was rarely worn, this thesis would not be consistent with the supposed eighteenth-century origin of the work. Eighteenth-century netsuke were utilitarian objects—it was not until the early nineteenth century that they came to be valued as works of art.

Both figures have well-carved arms and hands with carefully defined fingernails. For conclusive evidence of deliberate forgery, we must turn to technical analysis of the two netsuke and specifically to an examination of the cracks in the ivory. A natural crack in ivory always starts at a deep point and grows outward. Thus in a genuine crack there is always a wide point with tails which become thinner as the fissure extends outward. Furthermore, ivory cracks along the grain, not at an angle to it. Dirt tends to accumulate in a crack, making it appear black.

The expert forger can produce an ivory netsuke with the cracks characteristic of age in two ways—he can recarve a piece of eighteenth-century ivory, or he can use chemicals or other means to induce cracks in new ivory.

The only genuine crack in the forgery can be seen in the rear view at the bottom

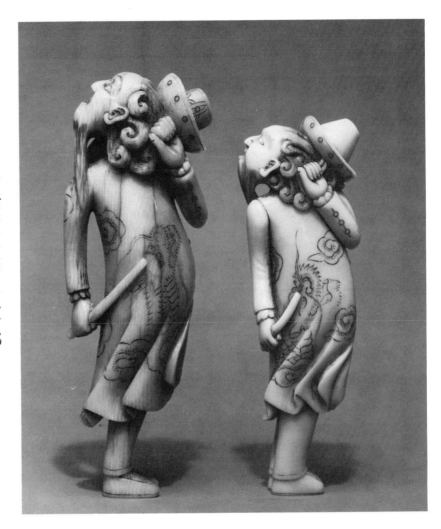

99,100. The Dutchman on the left is a twentieth-century netsuke apparently intended to look like an older piece. The netsuke on the right was created during the late eighteenth or early nineteenth century. A comparison of the two yields evidence that the netsuke on the left is a forgery of high quality.
99. Twentieth century. Ivory, height 4 inches, Gift of Mr. and Mrs. Burton Krouner, 1974, 1974.77 100. Late eighteenth–early nineteenth century. Ivory, height 3½ inches.
Gift of Charles A. Greenfield, 1977.264.9

of the tunic, extending outward and up from the inside of the garment. The most obvious artificial crack is the one on the forehead, which veers sharply away from the grain. Under extreme magnification it becomes clear that what appears to be a crack is actually stain painted on by the forger. Furthermore, an examination of the eye of the dragon shows that it was carved *after* a crack was created. Even more important is the fact that we find deep red stain in the crack rather than dirt.

It is important to understand the different ways in which artificial cracks can be created. Almost any radical, sudden atmospheric change can crack ivory. For example, it can be placed in boiling water, then in cold water, and then back in boiling water. It can be baked slowly in the oven. There are many chemicals which can produce spot heating which causes cracks. Carefully controlled pressure or a blow with an awl can open a fissure. The use of a thin pointed instrument such as a wedge or an awl can create a tiny valley which, when stained, looks like a crack. Most of the cracks visible on the front of no. 99 are simply painted on with the same stain used to fill the other artificially created crevices.

Patination, as well as cracks, is important in giving a netsuke a feeling of age.

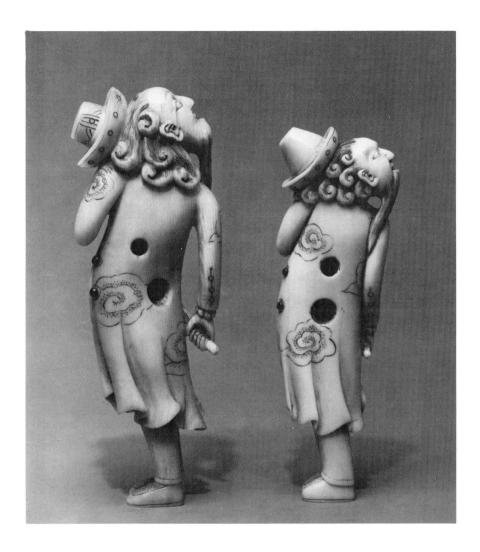

Patination is achieved in one of two ways: by time, accompanied by chemical reaction with human oils from rubbing, which forms a "skin" as in no. 100, or by machine polishing with appropriate chemicals as in no. 99. A high polish may be mistakenly perceived as "skin," the special shine found on aged ivory. There are polymer resins that, properly applied, give the surface a shiny, extraordinarily hard finish which is almost impervious to any kind of simple external testing. In the final analysis, the distinction between natural "skin" and a machine polish can only be made by a trained eye and sense of touch.

Genuine patination is also the result of exposure to light. The side of the netsuke which has been exposed to light—that is, the side worn away from the body— retains its original color or, if it has been exposed to strong light, becomes bleached. The other side, which has not been exposed to light, darkens. The degree of darkening depends upon the type of ivory and the atmospheric conditions to which the piece has been exposed. During the nineteenth century it became common to stain netsuke to give them the appearance of age or to hide defects in the ivory itself. The forgery we are examining here was stained a peach color, but the color is even and uniform

An expert forger can produce an ivory netsuke with cracks characteristic of age. A natural crack in ivory always starts at a deep point and grows outward; thus there is always a wide point with tails which become thinner as the fissure extends. A close examination of the eye of the dragon of no. 99 reveals that the eye was carved *after* the crack was created. Furthermore, red stain has been found in the crack, rather than dirt, which one would expect in a genuine older piece.

throughout the piece rather than having the highs and lows of naturally aged ivory. The staining was done with extraordinary skill, however, and would not raise any questions about the authenticity of the work were it not for the other problems we have noted.

We can conclude that no. 99 is a twentieth-century piece which was apparently intended to give the impression of being an older carving. Although certain stylistic deviations, such as the wrong style of hat and the artist's failure to continue the design of the garment into the folds, can be noted, conclusive evidence of forgery must depend upon the technical analysis described above. Forgeries continue to be produced, and artists become ever more skillful and sophisticated in their execution because of the development of new materials, techniques, and tools. For example, miniature electric dental drills make more precise and detailed carving possible and difficult to detect. Wood does not show signs of age for fifty years, and ivory can easily be altered to look old. The only advice to the collector is to learn as much as possible about the stylistic and technical aspects of netsuke, and to be wary and skeptical—*caveat emptor*.

Signatures

SIGNATURES DID NOT BECOME POPULAR on netsuke until the late eighteenth century, when individual carvers earned their reputation for a particular style. Some pieces were signed by a master although the work itself was done by a pupil; this was the highest attainment by a successful student. All of the signatures shown here are those of netsuke masters, and their characteristic way of signing a piece was, and still is, an indication of authenticity.

No. 2 No. 7 No. 8

No. 9 No. 10 No. 17 No. 18

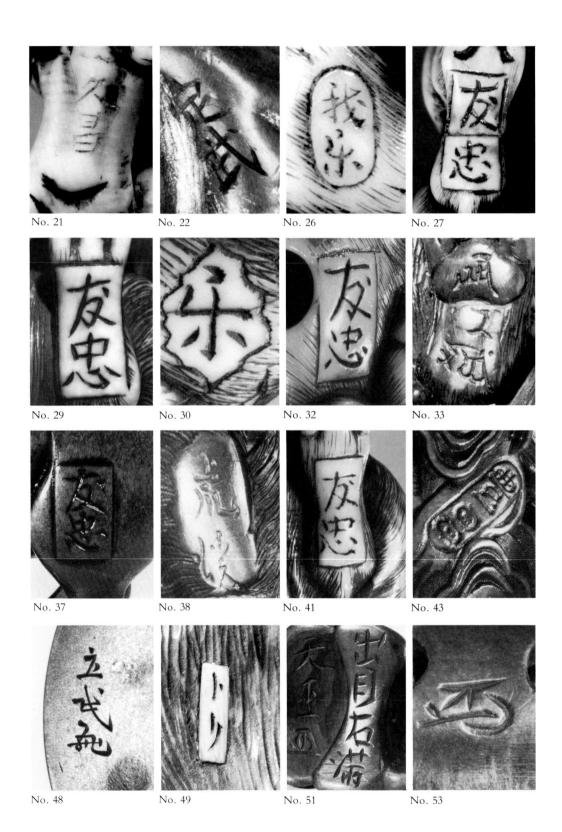

No. 21　　　　No. 22　　　　No. 26　　　　No. 27

No. 29　　　　No. 30　　　　No. 32　　　　No. 33

No. 37　　　　No. 38　　　　No. 41　　　　No. 43

No. 48　　　　No. 49　　　　No. 51　　　　No. 53

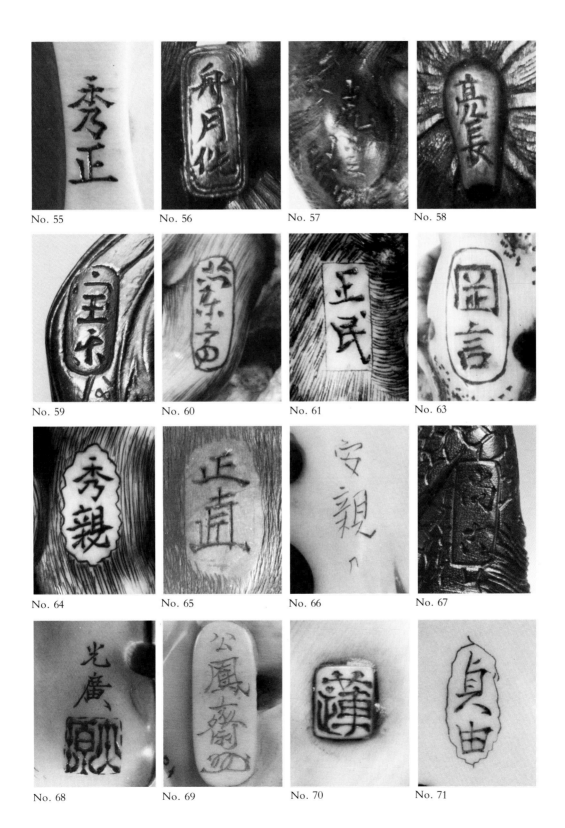

No. 55

No. 56

No. 57

No. 58

No. 59

No. 60

No. 61

No. 63

No. 64

No. 65

No. 66

No. 67

No. 68

No. 69

No. 70

No. 71

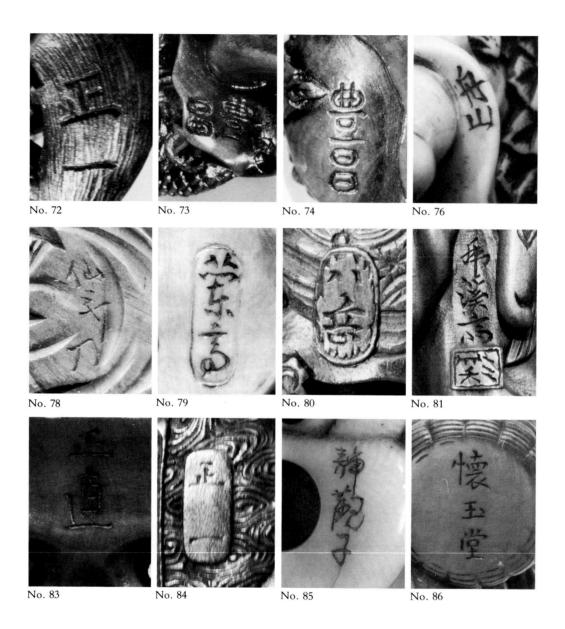

No. 72 No. 73 No. 74 No. 76

No. 78 No. 79 No. 80 No. 81

No. 83 No. 84 No. 85 No. 86

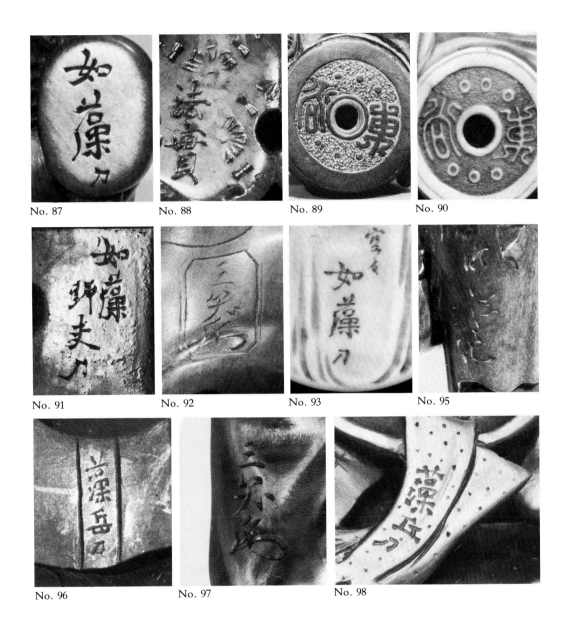

No. 87

No. 88

No. 89

No. 90

No. 91

No. 92

No. 93

No. 95

No. 96

No. 97

No. 98

A Glossary of Japanese Terms

akagane: copper alloy which, when "pickled" by chemical means, turns copper-red.

daimyō: feudal lord

hako netsuke: *netsuke* in the form of a covered box

himotoshi: openings or channels through which a cord is strung.

hinoki: Japanese cypress tree, cypress wood

horimono: carved or engraved object

ichii: yew tree, yew wood

inrō: Medicine or seal case of multiple compartments, attached by a cord to a *netsuke*

ittobori: single-knife stroke carving; creates flat angular planes

kagamibuta: type of *netsuke;* metal disk set into a shallow, round bowl which is usually made of ivory, metal, or wood

kakihan: artist's mark or stylized signature

kanamono: ornamental metal fitting

kinchaku: purse or money pouch

kiseru: tobacco pipe

maki-e: gold lacquer work

manjū: type of *netsuke* in the shape of a flat, round New Year's rice cake or bun

netsuke: small sculptural object, or toggle, usually worn to suspend objects hung from the sash of the kimono

obi: sash or belt of the kimono

obi hasami: type of elongated *netsuke* worn inside the *obi* which, unlike the straight *sashi netsuke*, has a hooked bottom, the hook pinching the lower edge of the *obi*

ojime: beadlike slide fastener

sagemono: hanging object, object suspended from the *obi*

samurai: warrior

sashi: type of elongated netsuke thrust inside the *obi*

shibuichi: copper and silver alloy which, when "pickled" by chemical means, turns a dark gray

tsuge: box tree, boxwood

umimatsu: sea coral or sea pine, ranging in color from deep pink to brown to jet black

ukibori: relief effect similar in appearance to embossing

yatate: portable container for writing implements

Bibliography

GENERAL

Anesaki, Masaharu. *Art, Life, and Nature in Japan*. Rutland and Tokyo: 1973.

Baer, N. S., and L. J. Majewski. *Ivory and Related Materials: An Annotated Bibliography. Section B. Working Techniques, Forgeries, and History*. New York: Institute of Fine Arts, June 1971.

Cammann, Schuyler. *Substance and Symbol in Chinese Toggles*. Philadelphia: 1962.

De Bary, William Theodore, ed. *Sources of Japanese Tradition*. 2 vols. New York, 1958.

Fijimaki. *Nihon no kitsuen go* [Japanese Smoking Tools]. Tokyo: 1965.

French, Calvin. *Through Closed Doors: Western Influence on Japanese Art, 1639–1853*. Rochester and Michigan: 1977.

Ihara, Saikaku, "Kōshoku ichidai onna" [Life of an Amorous Woman]. In *Nihon Koten Bungaku Taikei* [Collection of Japanese Classical Literature], vol. 47. Tokyo: 1957.

————. *The Life of an Amorous Man*. Translated by Hamada Kenji. Tokyo: 1964.

Keene, Donald. *Landscapes and Portraits: Appreciations of Japanese Culture*. Tokyo and Palo Alto: 1971.

Meech-Pekarik, Julia, et al. *Momoyama: Japanese Art in the Age of Grandeur*. New York: The Metropolitan Museum of Art, 1975.

Okada, Keishi. *Setsuyō gundan* [Regional, Historical, and Geographical Information on the Osaka and Hyogo area]. Osaka: 1701.

Paine, Robert T., and Alexander Soper. *The Art of Architecture of Japan*. Baltimore: 1955.

Ruch, Barbara. "Medieval Jongleurs." In *Japan in the Muromachi Age*, edited by John Whitney Hall and Tayoda Takeshi. Berkeley, Los Angeles, and London: 1977.

Tanizaki, Junichirō. *In Praise of Shadows*. Translated by Thomas J. Harper and Edward G. Seidensticker. New Haven: 1977.

Uyeno, Naoteru, ed. *Japanese Culture in the Meiji Era, Arts and Crafts*, vol. VII. Translated and adapted by Richard Lane. Tokyo: 1969.

Warner, Langdon. *The Enduring Art of Japan*. New York: 1958.

HISTORY AND RELIGION

Bellah, Robert N. *Tokugawa Religion: The Values of Pre-Industrial Japan*. Boston: 1970.

Eliot, Sir Charles. *Japanese Buddhism*. London and New York: 1969.

Hall, John Whitney. *Japan from Prehistory to Modern Times*. New York: 1970.

Kageyama, Haruki. *The Arts of Shinto*. Translated by Christine Guth. Arts of Japan vol. 4. Tokyo: 1973.

Keene, Donald. *The Japanese Discovery of Europe, 1720–1830*. Rev. ed. Stanford: 1969.

Nihongi: Chronicles of Japan from Earliest Times to A.D. 697. Translated by W. G. Aston. London: 1956.

Papinot, E. *Historical and Geographical Dictionary of Japan*. Tokyo: 1972.

Sansom, George. *A History of Japan: 1334–1615*. Stanford: 1961.

————. *A History of Japan: 1615–1867*. Stanford: 1963.

————. *Japan: A Short Cultural History*. Rev. ed. New York: 1962.

Taoist Teachings. Translated from the Book of Lieh Tzu by Lionel Giles. London: 1912.

The Ox and His Herdsman. Translated by M. H. Trevor. Tokyo: 1969.

Varley, Paul H. *Imperial Restoration in Medieval Japan.* New York and London: 1971.
———. *Japanese Culture, A Short History.* New York: 1973.
Waley, Arthur. *Zen Buddhism and Its Relationship to Art.* London: 1959.

LEGENDS

Anesaki, Masahiro, "Japanese Mythology." In *The Mythology of All Races,* edited by Canon John Arnott MacCulloch vol. VIII, pp. 207-387. Boston: 1928.
Edmunds, Will H. *Pointers and Clues to the Subjects of Chinese and Japanese Art.* 1934. Reprint. Geneva: 1974.
Joly, Henri L. *Legend in Japanese Art.* London: 1908.
Volker, Tys. *The Animal in Far Eastern Art.* 1950. Reprint. Leiden: 1975.

MASKS

Noma, Seiroku. *Masks.* Translated by Masaru Muro and Yoshiko Tezuka. Rutland and Tokyo: 1957.
Perzynski, Friedrich. *Japanische Masken Nō und Kyōgen.* 2 vols. Berlin and Leipzig: 1925.

NETSUKE

Bushell, Raymond. *Collectors' Netsuke.* Tokyo: 1971.
Davey, Neil K. *Netsuke.* London: 1973.
Hurtig, Bernard, comp. *Masterpieces of Netsuke Art.* New York and Tokyo: 1973.
Inaba, Tsuryu. *Sōkenkishō,* vol. VII. Osaka: 1781.
Makoto, Shichida. *Shimizugen (Shimizu Iwao) to sono ichimon* [Shimizugen/Shimizu Iwao [and his followers]. Tokyo: 1970.
Meinertzhagen, Frederick. *The Art of the Netsuke Carver.* London: 1956.
Okada, Barbra Teri. *Japanese Netsuke and Ojime: From the Herman and Paul Jaehne Collection of the Newark Museum.* Newark: 1976.
Ryerson, Egerton. *The Netsuke of Japan: Legends, History, Folklore and Customs.* London and New York; 1958.
The Netsuke Handbook of Ueda Reikichi. Translated and adapted by Raymond Bushell. Tokyo: 1961.
Ueda, Reikichi. *Shumi no netsuke* [Netsuke as a hobby]. Osaka: 1934.
———. *Netsuke no kenkyū* [The study of netsuke]. Osaka: 1944.

SCREENS AND PAINTINGS

Grilli, Elise. *The Art of the Japanese Screen.* New York and Tokyo: 1970.
Kondō, Ichitarō. *Japanese Genre Painting: The Lively Art of Renaissance Japan.* Translated by Roy Andrew Miller. Rutland and Tokyo: 1961.
Kyoto National Museum, ed. *Rakuchū Rakugai Zu* (Pictures of Sights In and Around Kyoto). Tokyo: 1966.
Okada, Jō. *Genre Screens from the Suntory Museum of Art.* Translated by Emily Sano. New York: Japan Society, 1978.

SCULPTURE

Kuno, Takeshi, ed. *A Guide to Japanese Sculpture.* Tokyo: 1963.
Merillat, Herbert Christian. *Sculpture—West and East.* New York: 1973.
Noma, Seiroku. *Japanese Sculpture.* Translated by M. G. Mori. Tokyo: 1939.
Warner, Langdon. *The Craft of the Japanese Sculptor.* New York: 1936.

Index